SINATRA

THE ARTIST AND THE MAN

ALSO BY JOHN LAHR

BIOGRAPHIES

Notes on a Cowardly Lion: The Biography of Bert Lahr

Prick Up Your Ears: The Biography of Joe Orton

The Orton Diaries (editor)

Coward: The Playwright

*Dame Edna Everage and the Rise of Western Civilization:
Backstage with Barry Humphries*

CRITICISM

A Casebook on Harold Pinter's The Homecoming
(edited with Anthea Lahr)

Up Against the Fourth Wall

Acting Out America

Life-Show (with Jonathan Price)

Astonish Me

Automatic Vaudeville: Essays on Star Turns

Light Fantastic: Adventures in Theatre

NOVELS

The Autograph Hound

Hot to Trot

PLAYS (adaptations)

Accidental Death of an Anarchist

Diary of a Somebody

The Bluebird of Unhappiness

The Manchurian Candidate

John Lahr

SINATRA

THE ARTIST AND THE MAN

PHŒNIX

A PHOENIX PAPERBACK

First published in the USA 1997 by Random House, Inc., New York,
and simultaneously in Canada by Random House of Canada Limited, Toronto

First published in Great Britain by Victor Gollancz in 1998
This paperback edition published in 1999 by Phoenix
an imprint of Orion Books Ltd,
Orion House, 5 Upper Saint Martin's Lane,
London WC2H 9EA

A shorter version of John Lahr's essay was originally published in
The New Yorker

A CIP catalogue record for this book is available from the
British Library.

ISBN: 0 75380 842 0

Designed and typeset by Production Line, Minster Lovell, Oxford
Printed and bound in Great Britain by
Butler & Tanner Ltd, Frome and London

SINATRA

THE ARTIST AND THE MAN

CONTENTS

This book began as a *New Yorker* essay and therefore owes its life to many hardworking people, especially Deborah Garrison, my expert editor, Ted Katauskas, the fact-checker, and Beth Tondreau. At Random House, Sean Abbott researched and edited the pictures and worked organizational wonders. Vicki Gold Levi and the *New Yorker*'s Kira Pollack and Mia Diiorio helped with the photo research. Also at Random House, I'd like to thank Kathy Rosenbloom (production manager), Benjamin Dreyer (production editor), and Deborah Foley (rights and permissions). At my house, I'd like to thank Connie Booth.

THE KING OF RING-A-DING-DING!

To get to the bustle of Manhattan from Hoboken, New Jersey, which is just across the Hudson River, takes about fifteen minutes by ferry; to forget the deadliness of the place took Frank Sinatra most of his lifetime. Sinatra was born in Hoboken, on December 12, 1915. In those days, from River Road, now called Sinatra Drive, you could see New York's crenellated skyline, rising like a bar graph of profits, and, if you walked to the dock's edge, the ass end of the Statue of Liberty. The vista was at once a thrill and a rebuke. As an adult, Sinatra often referred to his hometown as a "sewer"; after 1947, when he was given the key to the city, he didn't return to it officially until 1985, when he received an honorary degree from Stevens Institute of Technology, an engineering school that his ambitious mother had wanted him to attend. Dolly Sinatra, who had an immigrant's faith in success, wanted her school-shy son to become some kind of powerful man. In time, of course, Sinatra seized more than power; he infiltrated the Western world's dream life. His is "the most imitated, most listened to, most recognized voice of the second half of the twentieth century," the New York disk jockey William B. Williams said in the fifties, tagging him forever with the epithet Chairman of the Board. Sinatra, whose tape-recorded voice was heard by the Apollo 12 astronauts as they orbited the moon, and whose 206 CDs currently in print make him the most comprehensively digitally preserved music-maker in the history of recorded sound, referred to himself as the Top Wop. Even the Secret Service, which protected him when he produced presidential inaugurals for both John F. Kennedy and Ronald Reagan and whenever he lunched with Nancy Reagan at the White House, spotted the sense of manifest destiny in Sinatra. Its code name for Sinatra was Napoleon.

Sinatra's life was one long show of mastery over his Hoboken years, whose scars were harder to see than those on his neck, ear, and cheek from an agonizing forceps delivery that yanked the nearly thirteen-pound baby out of his twenty-one-year-old mother's diminutive body and prevented her from having other children. "His bravado, his bigness, the size of him in public life — it's part of him. But underneath there is something quite — I don't want to say 'sensitive' because that's an understatement — underneath there is a delicate, fragile boy," his daughter Tina Sinatra told me recently. When he was a young man, Sinatra's expectations were woefully at odds with his abilities. He wanted to build bridges, but he'd spent only forty-seven fractious days in high school; he wanted to be a sportswriter, but he was a "deez, demz, and doz" guy; he loved music, but he couldn't read it, and was too impatient to learn an instrument. "The story of Sinatra, of me, of all kinds of people of our time is that they had to cross the bridge either from Jersey or from Brooklyn to Manhattan and have people say 'You fit,' " the writer Pete Hamill says. (Hamill is the son of Irish immigrants, and a high-school dropout, whom Sinatra once approached to write his biography.) He adds, "You went there to sort of say, 'Hey, this is mine, too.' "

As a solitary latchkey kid, Sinatra would often wander down to the Hoboken wharves, dangle his feet over the docks, and stare at the cityscape, trying to imagine a future. "He didn't dream," Tina Sinatra insists, of her father's often repeated account of those days. "He said, 'I'm gonna do it. I'm gonna get across this river. I'm gonna go there and make a name for myself.' " At Sinatra's back — far from the river, in the shadow of the Jersey City Palisades — were the working-class warrens that first-generation Italians like his parents were trying furiously to climb out of. Hoboken had large Irish and German populations; Italians were at the bottom of the pecking order. As a young man, Sinatra's father, Marty, boxed as a bantamweight under the name Marty O'Brien, in order to be allowed to compete. Dolly, who had strawberry-blond hair and blue eyes, sometimes passed herself off as Mrs. O'Brien, and when they opened a bar during Prohibition, they called it Marty O'Brien's Bar.

Books have been written about Frank Sinatra's women, who were trophies to his success; but his squat, bespectacled mother — the outspoken daughter of a well-educated lithographer who brought his family to Hoboken from Genoa — had more to do with his success than

any of the countless babes with whom he was associated. Dolly spoke various dialects of Italian as well as a gamy version of English, and she was a popular local political figure, who at one time contemplated running for mayor. For a good portion of her adult life, she was a Democratic ward boss; she could guarantee the party machine at least five hundred votes at every election. She made things happen for others and for herself. Her son may have lacked for her attention when he was growing up (between the ages of six and twelve he was cared for during the day by his grandmother), but not for spending money. Sinatra was known as "Slacksey," because of his dapper, plentiful wardrobe (he favored an "Ivy League" look); even in the midst of the Depression, Dolly made sure that her moody boy had a circle of friends by providing him with a 1929 Chrysler and enough money to treat his cronies to sodas and movies. Sinatra's tenacity, drive, and cunning – and his way of walking the line between right and wrong – owed a lot to Dolly, who always had her eye on the main chance: in her time, she was both a midwife and an abortionist, a local politician and a Prohibition saloon keeper. "She was the force!" Sinatra said. "My son is like me," Dolly said. "You cross him, he never forgets."

"I think Frank was partial to his dad," says Nancy Sinatra, Sr., who was married to Frank throughout the fortics and is the mother of Nancy, Tina, and Frank, Jr. ("In Nancy I found beauty, warmth, and understanding: being with her was my only escape from what seemed like a grim world," Sinatra said of his three-year teenage courtship.) Sinatra's father was a quiet, passive man, while Dolly, a typical Italian *balabusta*, controlled the Sinatra household. "She was very strong and judgmental, and scared everybody," Shirley MacLaine says. Dolly had a stevedore's heart and mouth. "Son-of-a-bitch-bastard" was her most common curse; she called Sinatra's sidekick the saloon keeper Jilly Rizzo (and most everyone else) "fuckface"; she nicknamed her youngest granddaughter, Tina, "Little Shit." Among her grandchildren, Dolly favored Frank, Jr., whom she could idealize and pamper as she had her own son. "She always said to me and Nancy, 'When I'm dead, everything goes to Frankie. You girls get nothing,'" Tina Sinatra says. "She was a difficult woman. She always gave Dad a tough time." Her ambivalence toward Sinatra started at his difficult birth. "I wanted a girl," she said. "I bought a lot of pink clothes. When Frank was born, I didn't care. I dressed

him in pink anyway. Later, I got my mother to make him Lord Fauntleroy suits." Even though Dolly spoiled the child, she didn't spare the rod. She kept a piece of wood the size of a billy club behind the bar at home. "When I would get out of hand, she would give me a rap with that little club; then she'd hug me to her breast," Sinatra told Hamill one night in the seventies as they discussed the singer's erstwhile biography in a Monte Carlo hotel room. Hamill adds, "Then Sinatra said, 'I married the same woman every time.' That's Ava. That's all the women. He had this mother who punished and hugged him, and they were all part of the same thing."

From the start, Sinatra embraced and bullied the world as his mother had embraced and bullied him. "All of Dolly's ambitious energy was thrust into him," Tina Sinatra says. One episode in Sinatra's youth bears witness to this. Dolly had prevailed upon her son's godfather and namesake, Frank Garrick, who was the circulation manager of the *Jersey Observer*, to get her son a job. Sinatra duly found work on the paper's delivery truck. When the *Observer*'s sportswriter died, Dolly got Sinatra to go back to Garrick and ask for the writing job. Sinatra arrived at the paper dressed for reporter's work, but Garrick was out; undeterred, Frank sat at the dead writer's empty desk and went through the motions of doing the job. When the editor asked Sinatra to identify himself, he answered that he was the new sportswriter and that Garrick had sent him. His lie was discovered when Garrick arrived, and his godfather was forced to fire him. "Oh, the temper and the words and the filthy names he called me . . . like he was going to kill me," Garrick told Kitty Kelley in *His Way*, her unauthorized biography of Sinatra. "He called me every terrible name in the book and then he stormed out. He never said another word to me until fifty years later, after his mother died. She wrote me off, too, and even though we lived in the same town, she never said another word to me for the rest of her life."

Over the years, Dolly and her son also went through periods of not speaking. "Nancy, our mother, wasn't good enough," Tina Sinatra says. "Then, all of a sudden, she was good enough. When Ava was on the horizon, this was against God, how can he do this? But then the press turned in their favor. They became Romeo and Juliet, with his mother keeping them apart. Dolly changed her whole attitude. She always gave Dad a tough time." There was another Mexican standoff after Sinatra

announced his engagement to his fourth wife, a former Las Vegas showgirl, Barbara Blakeley Marx, whom he married in 1976. "I don't want no whore coming into this family," Dolly said. She always had to be disarmed, and Sinatra learned early how to practice a charm offensive. "She was a pisser, but she scared the shit outta me. Never knew what she'd hate that I'd do," he told Shirley MacLaine in her memoir *My Lucky Stars*. MacLaine adds, "Frank told me he feared and emulated his mother simultaneously."

Dolly enjoyed singing, especially at weddings and at political beer parties, but she didn't want her son to be a singer. "Dolly didn't have faith in what he wanted to do," Nancy Sinatra, Sr., says. "When he started to sing, it was no big deal." The notion had first dawned on Sinatra when he was about eleven and was in his parents' bar, where there was a player piano in the front room. "Occasionally, one of the men in the bar would pick me up and put me on the piano. I'd sing along with the music on the roll," Sinatra said in a 1986 lecture he gave at Yale University. "One day, I got a nickel. I said, 'This is the racket.' I thought, It's wonderful to sing. . . . I never forgot it." Under pressure to make something of himself, Sinatra increasingly focused on the one asset he was sure he possessed: his voice. "In my particular neighborhood in New Jersey, when I was a kid, boys became boxers or they worked in factories; and then the remaining group that I went around with were smitten by singing," Sinatra said during a 1980 radio broadcast. "We had a ukulele player, and we stood on the corners and sang songs." Sinatra told Shirley MacLaine that even as a young boy "he heard notes, and chords, and different musical values." Sinatra liked to listen to Gene Austin, Rudy Vallee, Bing Crosby, Russ Columbo, and Bob Eberly – but of all of them he idolized Crosby, whose casual sailor's cap and pipe were props that Sinatra himself would soon adopt. As his ambition to sing grew, so did Dolly's hectoring. "In your teens, there's always someone to spit on your dreams," Sinatra said. When Dolly saw a photo of Crosby in her son's room, she threw a shoe at Sinatra and called him a "bum." (Marty echoed his wife. " 'Do you want to get a real job or do you want to be a bum?' " Sinatra recalled to Arlene Francis on a radio show. "He didn't speak to me for one year. One whole year.")

Sinatra moved out of the house for a while, but when Dolly realized that she couldn't break her son's will she tried to empower it. She

chipped in for the orchestrations Sinatra rented to local bands who, as part of the deal, took him along as singer; she bought him portable speakers and a microphone, which increased his appeal to bands; she used her influence to help him hustle gigs at roadhouses, Democratic party meetings, nightclubs, and even Hoboken's Sicilian Cultural League. In 1935, still living at home, Sinatra took Nancy to the Loew's Journal Square in Jersey City to see Bing Crosby. "It was a very exciting moment for both of us, but for Frank it was the biggest moment of his life," says Nancy, Sr., who was then seventeen-year-old Nancy Barbato and whose father, a plastering contractor, gave Frank part-time work as a plasterer. "Bing had always been his hero, but watching him perform seemed to make it all come alive for him. I mean, he loved to sing; he'd sing at parties, he sang for me all the time, and he used to take me along on some of his appearances around town. But I don't think he really believed it. I don't think he believed it would ever really happen for him until that night. 'Someday,' he told me on the way home, 'that's gonna be me up there.' " Sinatra too remembered the night. "I knew I had to be a singer. But I never wanted to sing like him, because every kid on the block was boo-boo-booing like Crosby. My voice was up higher, and I said, 'That's not for me. I want to be a different kind of singer.' " He may have set out to be different than Crosby, but he was first billed as "New Jersey's Bing Crosby of the Air." Sinatra had attached himself to a trio in nearby Englewood called the Three Flashes. "Frank hung around us like we were gods," the trio's baritone, Fred Tamburro, told Kitty Kelley. "We took him along for one simple reason. Frankie-boy had a car." When the Three Flashes — all Italian kids looking for a leg up — were asked to do some movie shorts for Major Bowes, whose radio *Amateur Hour* was the most successful show on the air, Sinatra wanted to sing with them; they turned him down. Dolly quickly intervened, and before long the Three Flashes became the Hoboken Four. On September 8, 1935, they appeared on the millionaire Major's show, singing the Mills Brothers' hit "Shine." Major Bowes had begun the evening by incanting the show's catchphrase, which tapped into the hunger and the hopefulness of the listeners, and gave the program, like American society itself, the exciting sense of a sweepstakes: "We start the dizzying spin of the wheel of fortune," he said. "And where she stops, nobody knows." Sinatra's first words in public were at once pushy and playful; they got a laugh. "I'm Frank, Major," he said. "We're

looking for jobs. How about it?" The Hoboken Four won that night, with forty thousand people calling in – the largest vote up to then in the show's history.

From that first moment, the public took Sinatra in with an affectionate avidity that he could never call forth from his mother. "She always expected more of him," Nancy Sinatra, Sr., says. "It was never enough. For her, the cup was always half empty. It was difficult to please her." Lauren Bacall, who was briefly engaged to Sinatra in the fifties, recalls: "When I was around him, I always had the impression he couldn't stand his mother. He became uncontrollable at times. He'd explode." She goes on: "You just knew that good stuff was not there." In Dolly's eyes, her son could do no wrong and do no right. "She was tough with him," Sinatra's good friend the novelist Leonora Hornblow says. "She adored him and she was very proud of him, but she hardly ever said so." Dolly saw his success but never saw the person – a fact that Sinatra laughed about years later, when, after Marty's death, he'd moved her into palatial comfort in Rancho Mirage, California. (Dolly had a five-bedroom house, with a cook, a gardener, three maids, and security guards.) "She thinks she's the big hit," Sinatra said in a 1975 television interview. "If she were here with us now and she wanted to say something about me, she'd refer to me as 'Frank Sinatra.' While I'm sitting here."

Beyond talent, beyond technique, the palpable but invisible power of every great star stems from the need to be seen and to be held in the imagination of the audience. This is especially true of Sinatra. The stillness, attention, and unequivocal adoration that were never there in Dolly were undeniable in the rapt enthusiasm of his listeners. "Thank you for letting me sing for you" was often Sinatra's exit line at the end of his concerts. Sinatra lived to sing; his passion to connect and to be held by an audience released a bewildering energy from the public and from him. "The source of his energy was unfathomable," Shirley MacLaine writes in *My Lucky Stars*. "I don't think it comes simply from drive, or ambition, or the pulsating fear of being left behind. It has more to do with remaining a perpetual performing child who wants to please the mother audience." Bing Crosby once observed that Sinatra was unique in creating "a mood when he sang"; the mood was a collusive sense of intimacy. "The emotional loyalty that was paramount to him was never in doubt," Shirley MacLaine writes. "His audience was absolutely and

without reservation his. He'd never allow their attention or focus to stray." It was not infrequent for the paying customers to come away from a Sinatra concert thinking he'd sung just to them, an indication of just how deeply the public surrendered itself to the idea of him. In song, he was his best self, and he craved to see that goodness reflected in the adoring eyes of others. "His survival was his mother audience," MacLaine, who often toured with Sinatra, writes. "He desperately needed her to love him, appreciate him, acknowledge him, and never betray his trust. So he would cajole, manipulate, caress, admonish, scold, and love her unconditionally until there was no difference between him and her. He and she had become one." Offstage, Sinatra was dubbed "The Innkeeper" by his friends because of the largesse of his hospitality; onstage, he operated more or less the same way. He fed others to ensure that he got what he needed.

"Frank is a singer who comes along once in a lifetime, but why did he have to come in my lifetime?" Bing Crosby once joked. Sinatra's voice was smaller and lighter than Crosby's, but, as Whitney Balliett observed in *The New Yorker*, "his phrasing and immaculate sense of timing gave it a poise and stature Crosby's lacked." Sinatra's phenomenal impact, however, had to do not just with musical timing but with the timing of the technology that saturated the nation with his sound. As Henry Pleasants notes in *The Great American Popular Singers*, in 1930, only a decade before Sinatra made his name, the reigning crooner, Rudy Vallee, threw away the megaphone that had broadcast his sound and, by linking a borrowed NBC carbon microphone to amplifiers and several radios onstage, created a crude kind of concert amplification. ("I sing with dick in my voice" is how the notoriously foulmouthed Vallee explained his appeal.) Because of the lack of sophisticated miking technology, singers had had to sing in high ranges to play the room and to be heard above jazz bands. The microphone changed all this, bringing intimacy and articulation to the forefront of popular singing and making possible a whole new expressive style, which relegated the belters of the previous era – Al Jolson, Sophie Tucker – to history. (In the same way, the new amplification modified the rhythm section of bands so that the bass replaced the tuba and the rhythm guitar the banjo.)

Sinatra himself began by singing with a megaphone ("Guys would try to throw pennies in it," he said), but the microphone soon became his

totem. "I use all the color changes I can get into my voice," Sinatra said. "The microphone catches the softest tone, a whisper." "To Sinatra, a microphone is as real as a girl waiting to be kissed," E. B. White wrote in *The New Yorker* in 1952. Sinatra said, "Many singers never learned to use one. They never understood, and still don't, that a microphone is their instrument." As Ava Gardner shrewdly observed in her autobiography, "The ability to flirt with the entire audience is one of Frank's primary gifts as a performer." Gripping the stationary mike with both hands and only occasionally moving it back and forth, Sinatra used it as a prop in a kind of foreplay. "You don't crowd it, you must never jar an audience with it. . . . You must know when to move away from the mike and when to move back into it," he wrote in *Life*. He added, "It's like a geisha girl uses her fan."

Sinatra was an innovator who also caught the wave of other sound innovations that were making song a pervasive part of daily American life. "I am going to be the biggest singer that ever was," Sinatra told one friend, the songwriter Sammy Cahn, who was with Sinatra at the swank watering hole the Rio Bamba on the March 1943 night when he moved up from wowing bobby-soxers to wowing adults. Backstage after his debut, Sinatra threw his arms around Cahn. "Did I tell ya? Did I *tell* ya?" he said. According to Nick Servano, who was Sinatra's gofer during his meteoric rise, Sinatra "was like a Mack truck going one hundred miles an hour without breaks." Servano continues: "He had me working around the clock. 'Call Frank Cooper. Do it now. Don't wait until tomorrow,' he'd say. 'Send my publicity photos to Walter Winchell.' 'Get my records to the Lucky Strike *Hit Parade*.' 'Call Columbia Records and tell them I'll be singing such and such.' Frank knew so much about promotion and how to hype himself. He never once let up – not for a minute." Even before he'd broken through, Sinatra understood the poetry of broadcasting technology. "He made an informal survey of the habits of people who liked to listen to singers on radio and concluded that they could be divided into four significant groups – the early morning birds, the lunchtime devotees, the teatime gang, and the insomniacs," E. J. Kahn wrote in his three-part 1946 *New Yorker* profile on Sinatra and his phenomenon. "He wangled introductions to officials of three local stations and offered to sing over the air without charge. All three took him up, and he was soon singing eighteen times a week – at dawn, at

noon, and at five o'clock in the afternoon, as well as at the roadhouse later on. (One of the stations paid him seventy cents a week for car fare.)" Sinatra wanted to be everywhere at once; technology was finding new ways to broadcast the voice and make his Faustian daydream come true. Besides the orchestra platform, the nightclub floor, and the radio hookup, there were many new shop windows where he could sell himself. By 1938, according to the F.C.C., more than half of all broadcast programs were recordings of popular music. In 1933, there were 25,000 jukeboxes in the land; by 1939, there were 225,000, and by 1942, 400,000. The car radio, which was introduced in 1923 and became a standard feature by 1934, completely transformed the automotive experience. Record sales, which had dipped to $5.5 million in the depths of the Depression, had rebounded by 1940 to $48.4 million, and, by 1945, when Sinatra was a household name, reached their all-time high of $109 million. Muzak, which had been successfully tested in New York hotel lobbies and dining rooms in 1934, had become a fact of industrial life by 1940 as America geared up for war. Because of a new belief that music in the workplace increased comfort and efficiency, the Muzak system was installed in factories around the country to increase productivity. By the time Sinatra emerged from his brief apprenticeship as a ballad singer with touring dance bands and attained the status of solo act, the technology of enchantment was in place. The Sinatra phenomenon – what the press called "Sinatrauma" – was the century's first confounding spectacle of a spellbound society.

At first, Sinatra was more certain of his ability to enchant than was the trumpeter Harry James, whose struggling band he toured with for six months. James's then wife, the singer Lois Tobin, had heard Sinatra on the radio and suggested James drive out to Route 9W in Englewood Cliffs. When James rolled up to the Rustic Cabin with his new girl singer, Connie Haines, in tow, he asked the club's manager if they had a singer. " 'We don't have a singer,' " James recalled the manager saying. " 'But we do have an emcee who sings a little bit.' " James stayed to hear the emcee sing. " 'Well, what a voice!' " Connie Haines remembers James telling the young Sinatra, when James called him over to their table at the Rustic Cabin to offer Sinatra his first big break. "Then James said, 'We gotta change that name.' Frank pushed his tie up and made a direct turn. He

says, 'You want the voice, you take the name.' This is the truth. I was *there*." James wanted to rename Sinatra "Frankie Satin." Connie Haines recalls Harry James "sent the manager after Frank – the two egos were something else – and Frank came back. He said, 'Keep your name, keep your name.' Frank joined the band the next day, and we were boy-girl singers." Haines continues: "He was skinny and scarred up and all sorts of things, but just oozed sex appeal. He gave them that aloof attitude: 'I'm the best, the greatest, just try to catch me.' That was his attitude. I'm sixteen years old and I'm thinking, 'Gosh, what's this I feel. . . .' " According to Earl Wilson's 1976 biography of Sinatra, when *Down Beat* asked James the name of his new singer, he replied, "Not so loud! The kid's name is Sinatra. He considers himself the greatest vocalist in the business. Nobody ever heard of him, he's never had a hit record, he looks like a wet mop. But he says he's the greatest." James went on, "If he hears you compliment him, he'll demand a raise tonight." Sinatra's six-month stint with Harry James, in which their most memorable record, "All or Nothing at All," sold only about eight thousand copies in its first release, was an exciting, hardscrabble life. Sinatra, who had married Nancy in February 1939, was on the road with his now pregnant wife and inventing himself as a heartthrob. "Sinatra learned a lot from Harry," Lois Tobin told Will Friedwald in *Sinatra!: The Song Is You*. "He learned a lot about conducting and a lot about phrasing. I know they had a lot of mutual admiration for each other." Sinatra saluted James's "real know-how as a musician" and called his time with the band "a wonderful six-month experience." But according to a *Down Beat* poll in December 1939, the Harry James Band had slumped to number twelve in the top dance bands; Sinatra was looking for a bolt-hole. That same month, when Sinatra learned that the number one bandleader in the country, Tommy Dorsey, was going to be at the Rustic Cabin, he arranged to be guest singer. "Once in my life I saw something that might happen and I tried to plant it," Sinatra said. "And that was to sing with the Tommy Dorsey Orchestra. I wanted to do it in the worst way."

In January 1940, Sinatra jumped ship. James was gracious about letting Sinatra out of his contract. "Nancy was pregnant, and we weren't even making enough money to pay Frank the seventy-five dollars he was supposed to get," James told a radio interviewer. "So he went with Tommy Dorsey, and I said, 'Well, if we don't do any better in the next six

months or so, try to get me on, too.' " Sinatra had flirted with other big bands. "I wanted very much to go with Glenn Miller – and he said he'd take me – but in those days he didn't *feature* the vocalist," Sinatra told *Life* in 1971. "His musical arrangements very much took precedence over the singer." He went on: "I've often thought how different things might have been if I'd gone with Miller. Probably wouldn't be here tonight, that's for sure." Sinatra joined Tommy Dorsey's band for a hundred dollars a week. Sinatra was replacing the popular Jack Leonard, who had gone into the military. "It was like going from one school to another," Sinatra said, about joining the Dorsey band. "I was going to meet a whole new group of people, and I was really kind of frightened. I faked a couple of tunes, but we did all right with the audience. I was cold-shouldered by that whole band. They loved Jack Leonard, and I think they were saying, 'Well, let's see what he can do.' "When Sinatra made his New York debut at the Paramount in March, Leonard himself, along with the jazz trumpeter Pee Wee Erwin and the pianist Joel Herron, who later composed "I'm a Fool to Want You," went along to hear Dorsey's new singer. "We went there essentially to see the kid get killed," Herron, who sat in front between Leonard and Erwin and watched Sinatra, told Will Friedwald. "The band came on and did 'Sentimental Over You,' the theme, and Dorsey came forward and said, 'Without any further ado we'd like to introduce our new boy singer, Frank Sinatra, singing our hit record "Who," ' which Leonard had recorded in 1937. When this new kid came running out, we all were sure he was gonna fall on his ass. But when he started to sing, I sunk down in my seat. I felt humiliated for Leonard, who had just become the oldest kind of news that there was in the world."

"You could almost feel the excitement coming up out of the crowds when that kid stood up to sing," said Dorsey, whom Sinatra made the godfather of his firstborn child, and who taught Sinatra a lot about style – "to be a doer, not a talker." "Remember, he was no matinée idol. He was just a skinny kid with big ears. I used to stand there so amazed I'd almost forget to take my own solos." In fact, the secret of Sinatra's vocal impact lay primarily in his observations of Dorsey's trombone playing. "Dorsey would take a musical phrase and play it all the way through seemingly without breathing for eight, ten, maybe sixteen bars. How in the hell did he do that?" Sinatra told his daughter Nancy, in her book *Frank Sinatra: An American Legend*. "I used to sit behind him on the

bandstand and watch, trying to see him sneak a breath. But I never saw the bellows move in his back. His jacket didn't even move. So I edged my chair around to the side a little and peeked around to watch him. Finally, after a while, I discovered that he had a 'sneak pinhole' in the corner of his mouth – not an actual hole but a tiny place he left open where he was breathing. In the middle of a phrase, while the tone was still being carried through the trombone, he'd go 'shhh' and take a quick breath and play another four bars."

Dorsey claimed he taught Sinatra, in his own words, "to drive a ballad"; over the two years Sinatra was with the band, he got his real musical education. "I used to watch them if they did one-nighters at Roseland," Sinatra recalled. "I'd stand in front of the bandstand and watch how Tommy handled the singers with such finesse. They were show-cased, in other words. It wasn't a matter of an introduction, a vocal chorus, orchestra, and out. He would set a singer up so that the singer would sing the first chorus, the orchestra would play a small piece of music, a turnaround, and the singer would finish it." Sinatra continued: "Tommy was simpatico about vocalizing. Because the instrument that he played had the same physical qualities as the human voice." Dorsey streamlined both Sinatra's look and his way with a lyric.

Dorsey was a perfectionist. He pushed his musicians to their limits. "It wasn't a matter of *can* you do it, or *should* you try it, it was just *do* it!" Dorsey's drummer Alvin Stoller said. He went on: "Eventually you find yourself doing things that you didn't know you could do." Sinatra discovered that the combination of the audience response and Dorsey's rigor made him work harder. "The audience reaction meant that they liked me," he said. "I didn't know what was causing the reaction. I was experimenting with singing and different forms of phrasing and picking better songs." In his growing obsession with the fluidity of his sound, Sinatra was picking up on something that Dorsey tried to instill in all his instrumentalists.

Arthur "Skeets" Herfurt told Will Friedwald, "Tommy sometimes used to make the whole orchestra – not just the trombones – play from the top of a page clear down to the bottom without taking a breath. It was too many bars! But I sure developed lung power." So, too, did Sinatra. "I began using the pool at Stevens Institute of Technology whenever I had a chance, and I would swim underwater," Sinatra said. "The guys there

would say to me, 'Don't you ever swim on top of the water?' I said, 'No. There's a reason for it. I don't want to explain it.' But it did help me develop. I was very small. I weighed about one hundred and thirty pounds and I just had to grow a little more. I did a lot of exercises. I did running and that kind of stuff."

He also began listening seriously to jazz and classical musicians. "It is Billie Holiday, whom I first heard in Fifty-second Street clubs in the early thirties, who was and still remains the greatest single musical influence on me," Sinatra said. Like her, he became a preeminent engineer of intimacy. Sinatra was also indebted to the clarity and styling of Mabel Mercer, whom he called "the best teacher in the world." "Everyone who has ever raised his voice in song has learned from you," he wrote her, "but I am the luckiest one of all because I learned the most of all."

Around this time, Sinatra also became fascinated by the violinist Jascha Heifitz, who could "make a change of his bow in midphrase and get the end of the bow and continue without a perceptible missing beat in the motion," Sinatra told Arlene Francis. "I thought if that could be done on an instrument — and the violin and the flute are two good examples — why not do it with the human voice? It was tough to do. It took a lot of calisthenics and physical work to get the bellows — the breathing apparatus — built up."

Sinatra began to "play" his voice like Dorsey's trombone. "Over six months or so, I began to develop and delineate a method of long phraseology," Sinatra explained. "Instead of singing only two bars or four bars at a time — like most of the other guys around — I was able to sing six bars, and in some songs eight bars, without taking a visible or audible breath. That gave the melody a flowing, unbroken quality and that's what made me sound different." His sound astonished even the professionals. "After the first eight bars, I knew I was hearing something I'd never heard before," I was told by Jo Stafford, who had never seen or heard Sinatra before he walked onstage with her and the Pied Pipers for his debut with Dorsey. "Frank had such a mellow, quiet, romantic sound," says the lyricist and musical director Saul Chaplin, who won two Academy Awards for his work on Sinatra's *High Society* (1956) and *Can-Can* (1960), and who, along with his collaborator Sammy Cahn, wrote for Sinatra's voice at the beginning of his big career. "You hear it with no effort at all on your part. Most singers you're consciously listening to — with Frank, you just let it

bathe over you." Chaplin goes on: "He did a thing even then which makes a song very much more affecting. Let's take a word like 'mine.' Most people would say 'mine' – the 'i' would be important. But Frank it comes out mine. He lays on the consonant. That's interesting because most singers don't do it. They think the sound of the vowel 'mine' – is much more interesting than the 'n' sound. But, you know, you can do the 'n' sound much more softly. It helps sustain the line. It goes right into the next thing." "Sinatra brought a sense of seamlessness to his sound and to his show-biz destiny. Sinatra had that spark and great belief in himself," Dorsey's arranger Sy Oliver said. "You knew he was going to be big. When he walked out on that stage, you knew he was in charge. Tommy was like that."

If there was a pivotal moment when Sinatra and his sound came together with Dorsey and his orchestra, it was their New York nightclub debut, at the grand reopening of the fashionable Astor Roof, in May 1940. Benny Goodman and Oscar Levant were among the star-studded audience who watched Sinatra stop the show with his version of "Begin the Beguine." The audience wanted more; and while Dorsey was happy to ride the wave of their approval, he had no other Sinatra features in his band book. He instructed the band to play "Polka Dots and Moonbeams" and, after a four-bar introduction, went right into the "middle chorus." "The crowd went nuts," the pianist Joe Bushkin recalled. "Dorsey told Sinatra, 'Just sing whatever you want with Joe.'" Bushkin and Sinatra went into a piano-voice duet that stopped the fox-trotting dancers in their tracks but wrong-footed the twenty-three-year-old pianist. "As we were playing, I was trying to figure out his range," Bushkin said. "I was thinking quickly, 'Where is his top note?' If I can get to the top note, the bottom will take care of itself." They did a few tunes, including "All the Things You Are," and Bushkin was still struggling. "Then he turned around and said, 'Smoke Gets in Your Eyes,'" Bushkin said. "Well, if you know that tune, man, you know that you can really get lost in the middle part. Unless you really know what you're doing, that chord change will just lose you. I'm right out there without bread and water, man! Next thing I know, Frank was out there singing it all by himself, a cappella. I was so embarrassed. I mean, Jesus, all the guys were looking at me, so I just turned around and walked away from the piano! And that was the last song we did. I thought Tommy was going to kill me, but he thought it

was so funny." Bushkin went on: "And that is the night Frank Sinatra happened."

He happened fast. In fifteen months between 1940 and 1941, Sinatra recorded twenty-nine singles with Dorsey, appeared with Dorsey and the orchestra in two movies, *Las Vegas Nights* and *Ship Ahoy*, co-wrote and recorded "This Love of Mine," and was voted *Billboard*'s best male vocalist of 1941. Sinatra was already pondering the enormous gamble of going solo. When Sinatra was in Los Angeles playing the Hollywood Palladium, he'd drop in on Sammy Cahn and Saul Chaplin at their office across the street from Columbia Pictures. "His personality was no different then than now, except that he has acquired a little more polish and tact. Not very much," Chaplin writes in *The Golden Age of Movie Musicals and Me*. "He was intensely loyal, generous, arrogant, insolent, and a fierce battler for the underdog." At the time, according to Chaplin, Sinatra "used to talk endlessly about his career." In his book, Chaplin explains, "The kids were already crowding around the bandstand when he sang, and the 'oohing' and 'ahing' had already begun. He was becoming increasingly restless sitting on the bandstand waiting for his vocals. And he disliked always having to sing them in tempo so as not to disturb the dancers. The question was, could he make it alone?" Chaplin continues: "We decided it was a little too soon. He should make a few more hit records with Dorsey – he had already made 'South of the Border' – which would attract even more fans than he had then. He agreed. About six months later (he did 'I'll Never Smile Again' during this period), he finally did leave. . . ."

The decision remained a hard one. "I loved and admired the guy," Sinatra said of Dorsey. "He was a taskmaster and a brilliant musician, and I liked the way he made everybody toe the line. But he was also a man who detested the idea that a member of his orchestra would leave. He wanted the band to be set. I could understand that, because the orchestra was drilled like a platoon, and when new men arrived, it meant rehearsing and getting the guy to fit in. But I was earning a hundred and fifty dollars a week, and saw no future." Sinatra gave Dorsey one year's notice in September 1941. "I told him, 'Tom, I'm gonna leave the band a year from today.' Tommy said, 'Sure.' That's all," Sinatra said. About three months before Sinatra was to leave, he suggested to Dorsey that Dick Haymes replace him. Dorsey said, "No, no, no, you're not gonna leave this

band, not as easy as you think you are." Sinatra and Dorsey officially separated on September 3, 1942, in a farewell broadcast in which Sinatra handed over the male vocal responsibilities to Dick Haymes, who had stepped into Sinatra's shoes when he left Harry James and now for six months did the same with Dorsey. "I remember Frank left the band at the Circle Theatre in Indianapolis," Skitch Henderson told Will Friedwald. "I was with Jimmy Van Heusen when the phone rang one night, and it was Frank saying, 'The Old Man goosed me with his trombone for the last time. I'm leaving the band.'"

Getting free of Dorsey proved harder than Sinatra had fondly imagined. For about a year after his departure, Dorsey continued to collect an extortionate 43 percent of Sinatra's earnings. Inevitably, Sinatra bridled. He began mocking Dorsey as "Boss Tweed" in public, and turned their quarrel into a running radio gag. In one sketch for the 1943 *Broadway Bandbox*, Sinatra and the pint-sized burlesque comic Bert Wheeler are waiting for a hunting call; what they get instead is an out-of-tune trombone playing Dorsey's theme song "Sentimental Over You." "It's Dorsey coming to collect his commission!" Wheeler yells. Sinatra shoots back, "Again?" Even Edgar Bergen and his dummy Charlie McCarthy were scoring Sinatra-Dorsey jokes as late as 1945. Charlie McCarthy asks Sinatra if he could become his manager, and Sinatra replies, "Why shouldn't you be? Everybody else is!"

The Sinatra solo phenomenon began officially on December 30, 1942, at New York's Paramount Theatre, only three months after Sinatra made an acrimonious departure from Dorsey's band. "I hope you fall on your ass" was Dorsey's parting shot to Sinatra, who, with the help of his new agency, had engineered a cash buyout from his original contract. "When I left Tommy, things were quiet for a few months," Sinatra said. He moved his family prematurely out to Hollywood, then found himself back working theater dates in New Jersey, where the girls were swooning and his agents could get New York bookers to come across the river to the bigger venues. On his birthday, the booker for the Paramount, Bob Weitman, came to the Newark Mosque to see Sinatra sing but didn't come backstage. As Sinatra recalled in his Yale lecture, "I went home, and he rang me at the house and said – it was a famous phrase – 'What are you doing New Year's Eve?' I said, 'Not a thing, I can't even get booked anywhere. I can't find anywhere to work.' He said, 'I mean the morning

of December 31, and for a couple of weeks after that?' " Sinatra continued: "I said nothing. He said, 'I'd like you to open at the joint.' He used to call the Paramount 'the joint.' I said, 'You mean on New Year's Eve?' He said, 'That's right. That morning, you got Benny Goodman's Orchestra and a Crosby picture.' And I fell right on my butt! I couldn't believe what he said to me, to be put in a position like that. In those days they called you an extra added attraction. I went to rehearsal at seven-thirty in the morning. I looked at the marquee on Broadway, and it said, 'Extra Added Attraction: Frank Sinatra,' and I said, 'Wow!' "

As a favor to the management and to Benny Goodman, the comedian Jack Benny agreed to introduce Sinatra, a singer new to him. "I certainly didn't think Sinatra would get much of anything 'cause I never heard of him," Benny recalled. "So I did two or three jokes, and they laughed, and then I realized there were a lot of young people out there and they were probably just waiting for Sinatra. So I introduced him as if he were one of my closest friends. And then I said, 'Well, anyway, ladies and gentlemen, here he is, Frank Sinatra.' And I thought the goddamned building was going to cave in. I never heard such a commotion, with people running down to the stage screaming and nearly knocking me off the ramp. All this for a fellow I never heard of." At the din, Benny Goodman was heard to say, "What the fuck was that?" When Sinatra stepped onstage, he walked into pandemonium. "The sound that greeted me was absolutely deafening. It was a tremendous roar," Sinatra recalled. "I couldn't move a muscle." He continued: "I burst out laughing and gave out with 'For Me and My Gal.' " ("That Sinatra hit those kids right in the kidneys," a Paramount usher was quoted after the first momentous appearance. "At the end of the day, there was more urine on the seats and carpets than in the toilets.") It was a watershed moment for Sinatra, and one that he had planned carefully. "Sinatra knew where he was going from the first day," says Frank Military, who was Sinatra's aide de camp for nearly fifteen years and is now a senior vice president at Warner Chappell Music. "He planned his whole life out. He did. He said, 'I'm going to go out on my own, I'm going to get my own recording contract, I'm gonna be a big star.' He said it. You believed it."

Sinatra, who took voice lessons for his throat, ballet lessons for his hands, and elocution lessons for his speech, left nothing in his career to chance. "I believe in publicity," Sinatra said. "It's the best thing to spend

money on." He hired a new press agent, George Evans, to fan the flames of his blazing Paramount reception for the rest of his eight-week engagement. "Certainly things were done," Evans later told E. J. Kahn for his *New Yorker* profile. Earlier that year, Evans had mobilized fans to picket Tommy Dorsey with placards like DORSEY UNFAIR TO OUR BOY FRANKIE, which got wide news coverage and embarrassed "The Sentimental Gentleman" sufficiently to bring him to the bargaining table. Sinatra's spectacular Paramount engagement was another of Evans's exercises in crowd psychology, which helped to earn him *Billboard's* scroll for "Most Effective Promotion of a Single Personality" in 1943. "The dozen girls we hired to scream and swoon did exactly as we told them," Evans's partner Jack Keller told Kitty Kelley. "But hundreds more we didn't hire screamed even louder."

The booming frenzy was the beginning of the Sinatra era. "The spontaneous reaction corresponds to no common understanding relating to tradition or technique of performance, nor yet to the meaning of the sung text," a critic in the *Herald Tribune* wrote about the hysteria Sinatra induced. Sinatra himself was as bewildered as the pundits. "I was very confused," Sinatra said. "I had never seen it. . . . Nobody had ever heard that kind of reaction before." Other excellent band singers had tried to go it alone and failed: Jack Leonard, Bob Eberly, and, after a brief success, Dick Haymes. "Now when I sing, there is nothing to distract me," Sinatra said. "Thirty-three musicians in the Dorsey band. It was like competing with a three-ring circus. Now I'm there alone." He had fretted a long time about the move. "The reason I wanted to leave Tommy's band was that Crosby was number one, way up on top of the pile," Sinatra said during his Yale lecture. "In the open field, you might say, were some awfully good singers with the orchestras. Bob Eberly (with Jimmy Dorsey) was a fabulous vocalist. Mr. Como (with Ted Weems) is such a wonderful singer. I thought, If I don't make a move out of this and try to do it on my own soon, one of those guys will do it, and I'll have to fight all three of them to get a position." Sinatra was the first to break through, and his fabulous success proved to be the thin end of the wedge for the Big Band Era and the beginning of the Vocalist's Era. Within a month, his salary went crazy – from $750 a week to $25,000 – but not as crazy as his entranced fans. "Not since the days of Rudolph Valentino has American womanhood made such unabashed love to an entertainer,"

Time wrote. "Girls hid in his dressing rooms, in his hotel rooms, in the trunk of his car," Arnold Shaw wrote in his 1968 biography. "When it snowed, girls fought over his footprints, which some took home and stored in refrigerators." When Sinatra returned to the Paramount Theatre again, in October 1944, the line began forming before dawn and soon swelled to approximately twenty thousand fans, packed six abreast. Many members of the audience for the first show wouldn't leave the theater, and the frustrated crowd outside went berserk, in what became known as the Columbus Day Riot. Two hundred police, 421 police reserves, 20 radio cars, and 2 emergency trucks were called in to control the rampaging, mostly teenage, girls.

Plato called songs "spells for souls for the creation of concord"; Sinatra's crooning was balm to a republic desolated by the economic losses of the Depression and heading for war. "The popular song has that 'something' which makes people forget their troubles and cares better than any other medium," the publisher wrote in the preface to Sinatra's *Tips on Popular Song* (1941), which Sinatra "coauthored" with his voice coach, John Quinlan. "Never force the voice, for harsh tones eventually wear out the vocal cords," Sinatra wrote. In song, at least, Sinatra avoided harshness at all costs. "The best way to describe crooning is 'Don't make waves.' Sinatra's voice sings a straight line in a straight tone," Saul Chaplin says. "There are no sudden louds or softs. The oscillation of the sound waves isn't wide." Sinatra – or "Swoonatra," as he was dubbed – delivered a lullaby that excited the citizens to swoon rather than to riot. The depth of Sinatra's spell was best measured not in dollars but in newly minted words, whose roots were based on "Sinatra" and "swoon." Sinatra became not just a proper name to conjure with, but a vocabulary – "the most extravagant vocabulary ever constructed around one man," as E. J. Kahn noted. Among the new press coinages were Sinatrance, Swoonheart, Sinatritis, Swoonology, Sinatralating, Swoonatra, Sinatraceptive, Swoonatrance, Sinatramania, Swoonatic, Sinatrick, Swoonster, Sinatruck, Swoonery, Sinatractive, Swoondoggler, Swoonism, Sinatraless, Screenatra, Sinatrism, Sinatraphile, Sinatraphobe, Sinatraddiction, Sinatradition, Sinatrish, Sinatrabugs, Sinatraltitude, Sinatraing, Sinatroops, and Sonatra. Some pundits tried to stretch the notion of Sinatra to meanings beyond his power to enchant. In the gossip columns, Walter Winchell coined

"Sinatr'd" as a past tense for "cut up into several financial pieces"; and Dorothy Kilgallen used his name as synonym for "mobbed." To the teenagers who screamed for him, he was "Frankie"; to the world, he quickly became The Voice. The imperialism of Sinatra's stratospheric celebrity seeped into semantics; language bowed to his spell. The New York Paramount was called the "Para-sinatra." After a throat infection sent him to Mt. Sinai, the hospital became known in the press as Mt. Sinaitra and Mt. Sinatra. Sinatra himself seemed to inspire public hyperbole to register the size of his new presence in the land. He was described variously as the Lean Lark, the Croon Prince of Swing, Moonlight Sinatra, Swoonlight Sinatra, the Swoon King, the Swing-Shift Caruso, the Sultan of Swoon, the Swami of Swoon, Mr. Swoon, the Larynx, the Svengali of Swing, the Bony Baritone, the Groovy Galahad, and Too-Frank Sinatra. Sinatra's fans took to signing their letters "Frankly yours," and changing the notation for their postscripts from "P.S." to "F.S."

But Sinatra, whose instant stardom generated two thousand fan clubs, had another explanation for his appeal besides the spell of song. "I was the boy in every corner drugstore, the boy who'd gone off to war," he said. Actually, a punctured eardrum made him ineligible for service but available for leading roles. It was another piece of extraordinary good timing. The old stars were in the service, and the new ones wouldn't emerge until the end of the decade. Sinatra had an open field on which to sing and dance. In *Higher and Higher* (1943), he introduced himself to film audiences and to the girl next door with "Hi, I'm Frank Sinatra"; she promptly swooned. At the picture's finale, Sinatra appeared unsupported in a field of clouds in what James Agee called "an erotic dream." Agee went on, "He swells from a pinpoint to a giant. Higher and higher indeed. The Messiah Himself will have to sweat to work out a better return engagement."

By 1945, his apotheosis was complete. He won his first Academy Award for *The House I Live In*, a progressive ten-minute short about racial tolerance, and *Modern Screen* voted him the year's most popular movie actor. But on the homefront and in the war zones there was a residual animosity to any young man who had not fought for his country. "Why should their husbands, sons, and brothers be risking their lives while Frank was at home making millions?" Saul Chaplin wrote. Sinatra's star was secure enough, however, to take on a U.S.O. tour of the North

African theater of operations with Chaplin and Phil Silvers. "In almost every case, he faced a hostile audience of GIs," Chaplin wrote. "I mean that literally, because on many occasions soldiers showed us the fruit and vegetables they had brought. But gradually Frank won them over."

Sinatra's new influence even got him an audience with Pope Pius XII. Chaplin was with Sinatra when he met the Pope:

> POPE: I understand you're a singer.
> FRANK: Yes, Your Holiness.
> POPE: You are quite well known in America?
> FRANK: I've been most fortunate, Your Holiness.
> POPE: What do you sing? [He meant tenor, baritone, or bass.]
> FRANK: "Old Man River," "Night and Day," "The Song Is You," and
> other popular songs.

Sinatra may have drawn a blank with the Pope in the Old World, but back home he spoke to the heart of young America. In a "Why I Like Frank Sinatra" essay contest sponsored by a Detroit radio station in 1946, the winner wrote: "We were kids that never got much attention, but he made us feel like we were worth something." The songs Sinatra sang were little dramas of desire that he acted out; like all good drama, they were pieces of artifice, lies like truth. Sinatra's best acting was not on film but in song.

"When I sing, I believe, I'm honest," he told *Playboy* in 1963. "An audience is like a broad. If you're indifferent, Endsville." To the songwriter Carolyn Leigh, who wrote the lyrics to one of Sinatra's big hits, "Witchcraft," Sinatra's success was due to his willingness "to subject himself to the role he's supposed to play in a song." Sinatra instinctively approached song as acting. "You begin to learn to use the lyrics of a song as a script, as a scene. I didn't know I was doing that at the time, but I was," he said years later on TV. "I try to transpose my thoughts about the song into a person who might be singing that to somebody else. He's making his case, in other words, for himself." "Too much pash," *Billboard* said when Sinatra first came on the scene in 1939; but "pash" was exactly what made Sinatra so special and what set him apart from the detached Bing Crosby, whom Sinatra dethroned by 1943 in *Down Beat*'s poll of the nation's most popular singers. Sinatra's singing was quite literally

sensational; that is, he made ideas felt. Sinatra's scrawny frame (he had a twenty-nine-inch waist, weighed 130 pounds, and stood about five feet ten), his high voice, and his shy smile gave him a look of boyish innocence; he was a safe object for teenagers to adore. He personified the longing he sang about: "I'll never thrill again to somebody new," he sang famously in "I'll Never Smile Again"; in "This Love of Mine," whose lyrics he co-wrote, his sexual torment overwhelmed him: "It's lonesome through the day / And oh! the night." "Everything Happens to Me" struck another mood of collapse, where a sad sack Sinatra sings, "I guess I'll go through life / Catching colds and missing trains. . . ."

But there were other reasons for the depth of Sinatra's appeal. Sinatra's voice, his gaiety, and the exuberance of his romantic allure infused daily wartime life with a sense of the poetic, an attitude on which E. B. White shrewdly commented in *The New Yorker*. "War tends to remove the poetic content from our lives and from our sanity – we brood, we plan, we worry, we hate, and we destroy – and all mental activity of this nature is unpoetical since poetry is dreams and love and simple melancholy." There was something even more poetic in Sinatra's juicy, vulgar, turbulent success. He was the Jackie Robinson of Italian America. "He made it. And not only made it, but outdid what the other bastards did," Pete Hamill says. "For people like us, dropouts coming out of Brooklyn, he expresses for us what we can't express, and he does this by taking somebody else's work and appropriating it." Hamill adds: "It's like stealing a Cadillac. Except he's stealing George Gershwin."

Sinatra didn't just sing a song; he made it his own. "Look what he did with songs that were written in shows that never really made it – 'Little Girl Blue,' 'I Didn't Know What Time It Was,' 'Night and Day,' " Frank Military says. "Frank took those songs and made them into important standards. They otherwise would never have seen the light of day." Sinatra brought a special urgency to his proprietorship. "I always believed that the written word was first. Always first," he told Arlene Francis. "The word actually dictates to you in a song. It really tells you what it needs." "He sings and lives in the lyric," says the opera star Robert Merrill, who coached Sinatra occasionally in his later years. And the songwriters Sinatra embraced, especially after he went solo – Cole Porter, Ira Gershwin, Johnny Mercer, Alec Wilder, E. Y. Harburg, Arthur Schwartz, Sammy Cahn, Jerome Kern, Lorenz Hart, Oscar Hammerstein – were the

voices of the educated middle-class mainstream, whose sophisticated wordplay, diction, and syntax had an equipoise and a class that contrasted with the social stutter that so bedeviled Sinatra. "Frank was not articulate at all," Saul Chaplin says. He goes on: "The way he sang was nothing like the way he was as a person." According to Hamill, Sinatra built up his vocabulary doing crosswords, and in the seventies he was reading Strunk and White's *Elements of Style* for help with grammar. His signed articles were ghostwritten; considering the dimensions of his fame, he submitted to very few television interviews, and then only with friends like Arlene Francis or Aileen Mehle (in whose syndicated "Suzy" column he announced his first retirement, in 1971) – people he felt would protect him. Singing stops stuttering; and although Sinatra never stammered, singing eliminated other of Sinatra's confounding impediments. Once he was inside the lyric, he had command of the class postures and of the language that he found paralyzing elsewhere. I asked Dr. Oliver Sacks how singing could effect such a change. "I don't know what happens neurologically," Sacks says. "I think it's not just music, in the literal auditory or acoustic sense. I think it has something to do with the nature of flow." He goes on: "People with Parkinson's are said to have a 'kinetic stutter.' Their walking may have that irregular sort of quality, but they may be able to walk *with* somebody. The other person's ambulatory flow is sort of shared. Music or other people's walking can provide externally what the person can't provide internally."

"I'm happiest when I'm onstage all by myself with an orchestra and nobody to bug me," Sinatra said. Then, Sinatra was beyond the judgment of others: in control of not only his musical gift but of language. Lyrics provided a kind of scaffolding for Sinatra, through which he found new confidence and articulate energy. "I'm one of the worst readers of poetry in the world," he said. "But when I do it in song, I find that I enjoy it, and I find that I understand the distance per phrase." Song called the poetic out of him. When he opened his mouth in song, he was calm; he was smooth; he was sensitive; he had no hint of the Hoboken streets in his pronunciation; what he called his "Sicilian temper" was filtered through the charm of lyrics and music into poetic passion. In singing, the outsider found an unobtrusive way of getting inside. "My theory is not to break the phrase," he told Arlene Francis on her TV show. "Keep the audience listening to the rest of the phrase. To sing something and *not*

shock them by breaking the phrase." As an example, Sinatra used a line from "Fools Rush In": "You'll hear somebody say 'Fools rush in . . .' And breathe. '. . . Where wise men never go.' Breathe," Sinatra explained. "That should be one phrase: 'Fools rush in where wise men never go, 'cause wise men never fall in love, so how are they to know?' It tells the story right." With other singers – Vic Damone, for instance, and Tony Bennett – you admired the technique; with Sinatra you admired the rendition. He presented the song like a landscape he'd restored, painting himself into the picture so masterfully that it was impossible to imagine it without him. "He's the only man able to imply punctuation in his singing. He sings conversation like we're talking," Jonathan Schwartz, the author and radio personality, says, breaking into song himself. " 'You ain't been blue, no, no, no.' Comma. 'You ain't been blue, till you've had that mood indigo. . . .' Maybe a semicolon or a dash." Jo Stafford says, "He's one artist that can keep the great American songs alive. He's got enough fame, and enough of an audience, that he can continue to do these songs."

Sinatra's appropriations of the standards was also the acquisition of the manners of another class. " 'You see what they got?' " Hamill says Sinatra said to him in the seventies as they watched Hamill's children walk around the gardens of Monte Carlo. " 'They can go to the best schools. They can walk in everywhere, and they will know when they walk in what to do.' I said, 'What do you mean?' He said, 'Anything. Simple stuff. What fork to pick up.' " Hamill adds, "It's no accident that Sinatra aspired in the music to grace. The ballads, in particular, have a grace to them that is really extraordinary. And that's about knowing what fork to pick up."

A decade after Sinatra's Paramount triumph, a headline in the World Telegram & Sun put what he called his Dark Ages into bold relief: GONE ON FRANKIE IN '42; GONE IN '52. As early as 1948, Sinatra had begun to lose his hold on the public, a chastening fact that rocked Sammy Davis, Jr., who stifled a big hello when he caught sight of his falling idol across a Manhattan street. "Frank was slowly walking down Broadway with no hat and his collar up and not a soul was paying attention to him," he writes in his autobiography. "This was the man who only a few years ago had tied up traffic all over Times Square. . . . Now the same man was walking down the same street and nobody gave a

damn!" Sinatra never stopped working during these difficult years, producing some good songs – "Hello Young Lovers," "Birth of the Blues" – and even having the occasional bright moment in film (he was excellent in *On the Town*, despite the humbling switch in his billing from number one to number two, below Gene Kelly). But a new youngster, Johnnie Ray, had the nation's ear, and Sinatra's records no longer sold in their familiar quantities. "What do you think is happening?" he asked the columnist Earl Wilson. He added, "I'm not throwing in any sponge to Johnnie Ray!" Sinatra's career, his marriage, and his voice were showing visible signs of cracking under the pressure of his momentum, and the fans who had adored his crooning were not so adoring of his bad behavior, which they now read about regularly in the papers. In 1947, Sinatra managed to get himself photographed with Lucky Luciano and other mobsters in Havana, thereby giving the syndicated columnist Robert Ruark a three-part field day. SHAME, SINATRA! was the first column's banner. Then, there was the issue of Sinatra's egalitarian political opinions, which let him in for Red-baiting by the right-wing press; he was labeled a Communist in the F.B.I. files. CLEAR THE DECKS SINATRA CALLED RED was *Down Beat's* headline; they knew their musician. But of all Sinatra's sins, the most unacceptable to the public were his unabashed extramarital exploits. "I've talked to a lot of women who've been with him," Shirley MacLaine says. "They've said he likes to be mothered – mothered and smothered; that's different than cuddled." According to press reports, he appeared to be making an almost heroic effort to bed the female population of an entire industry – as though he were hell-bent on proving himself through conquest as his career dipped. ("I don't think his feelings ever ran that deep for women," Lauren Bacall says. "I think maybe for Ava. She left, you see. She's the one who left.") In the late forties and early fifties, he was frequently photographed with the objects of his desire, among them Marilyn Maxwell, Lana Turner, and, especially, Ava Gardner; it was a list whose ranks would ultimately include Joan Crawford, Marlene Dietrich, Kim Novak, Lauren Bacall, Angie Dickinson, Lee Remick, Carol Lynley, Eva Gabor, Gloria Vanderbilt, Natalie Wood, Rhonda Fleming, Marilyn Monroe, Sophia Loren, Debbie Reynolds, Gina Lollobrigida, Jill St. John, Anita Ekberg, Judy Garland, and Juliet Prowse. "Sinatra's idea of paradise is a place where there are plenty of women and no newspapermen," remarked Humphrey Bogart,

who was Sinatra's good friend and the model for his emerging "tough guy" persona. "He doesn't know it, but he'd be better off if it were the other way around."

Indeed, Sinatra, who had learned the importance of publicity from Dorsey, and had launched himself on the press with almost presidential lavishness in the forties (he bought the columnists dinners, jewelry, engraved gold Dunhill lighters), now lashed out at the journalists who were chronicling his decline. "To tell Louella Parsons to go fuck herself was quite a major thing in those days, when everybody was quivering," says Tony Curtis, one of the Rat Pack regulars. And Parsons wasn't the only writer to get a Sinatra jolt via Western Union. Erskine Johnson, a columnist for the *Los Angeles Daily News*, also heard from Sinatra. "Just continue to print lies about me and my temper – not my temperament. Will see that you get a belt in your stupid and vicious mouth," he wired. (Years later, Sinatra sent gossip columnist Dorothy Kilgallen a tombstone with her name on it.) Sinatra also took on Westbrook Pegler, who called him a "fellow traveler," and struck the *Daily Mirror*'s reactionary columnist Lee Mortimer on the side of the head – a blow that landed Mortimer on the floor and Sinatra with an out-of-court settlement that cost him twenty-five thousand dollars. "He gave me a look," Sinatra said before lawyers sanitized his explanations. "It was one of those 'Who do you amount to?' looks. I followed him out. I hit him. I'm all mixed up." (In a drunken moment after Mortimer died, Sinatra found his grave and pissed on it. "I'll bury the bastards. I'll bury them all," he said.) Nothing so infuriated Sinatra as being disregarded; unless, of course, it was being condescended to. He was voted "Least Cooperative Star" by the Hollywood Women's Press Club.

Sinatra's temper was becoming a controlling factor in his relationships as well as his public life. The force of his explosive unpredictability could be devastating. Sinatra's close friend Leonora Hornblow says, "It's instant. It's uncontrollable. It's like a volcano. You want to run away. He's got lungs, mind you. When he yells, you hear it." "People would literally shiver until they laughed when he erupted," Shirley MacLaine writes in *My Lucky Stars*. She continues: "I believe the reason for so much of Frank's emotional violence was his need to be understood on command. He couldn't wait. He, like many true artists, lived in the moment. That moment was so expansive, so full of uncontrollable feeling, that those

who didn't 'get it' were visited by his cruelty. His music was mathematical
perfection with no room for imprecision. He saw the truth in the same
way. Absolute – no deviation. He had to live in a world he created in
order to control it, and his talent and street-smart shrewdness enabled
him to do it."

MacLaine wasn't on the receiving end of Sinatra's abuse, but Lauren
Bacall was. "His unpredictability was exciting – it's always exciting –
except when he turned. When that happened, and the mood changed,
you just wanted to be somewhere else." She continues: "He gave this
New Year's Eve party in Palm Springs and I was supposed to be the
hostess. All of our mutual friends were there. He didn't speak to me. He
would not speak to me. I, of course, was in a complete state. I was in
tears. I didn't know what to do. I should've left. But I was lost. He never
spoke to me. The next day I picked up my suitcases to take to the car.
'You a bellboy? You carrying your own cases?' He suddenly became
another person. After that we did not see each other for a while."

Anyone who knew Sinatra well also knew what Sammy Cahn called
"the blue-eyed ray" – the intense beam of romance or rage that Sinatra
emitted. "That look he also locked into very young, like he did his
conception of women," Shirley MacLaine says. "He sort of gave me that
look which was a look between 'I'll protect you' and 'Do you want to
have an affair?' You couldn't tell when one stopped and the other started."
In her memoir *What Falls Away*, Mia Farrow, who was married to Sinatra
between 1966 and 1968, describes the unsettling effect of Sinatra's eye
lock. "He was talking," she writes. "I can't be sure of the words because
something else was happening too – a gathering of thoughts appeared in
his eye too and he pushed them into me." When Bacall was den mother
in the early fifties to the original Holmby Hills Rat Pack, which included
Bogart, the David Nivens, the Mike Romanoffs, Judy Garland, Spencer
Tracy, Nathaniel Benchley, and Sinatra, she, too, felt the powerful manipu-
lation of Sinatra's stare. In those days, according to Bacall, Sinatra "always
seemed to attach himself to a married couple that would be what he
always dreamed his life would be, but that he never would live. And Bogie
and I were it – a family and people who were still able to have fun."
Bacall continues: "When Frank looked at you, he had the quality of the
lost lonely little boy. I remember Bogie and I were staying at his house in
Palm Springs one weekend. We all went to a place called Ruby's. Frank

always had his hangouts. He'd always take you, and he had to be the host, of course. We were all sitting having dinner; then people were going to go home. We were going back to L.A. Frank was sitting there very forlorn-looking. I said to Bogie, 'God, he's so sad, maybe we shouldn't leave him alone. He's all by himself.' When Bogie and I were in the car driving home, he said, 'You know, Frank chose this life. He didn't have to live this way.' He said, 'We have to remember always what our life is, and not let Frank, in all his little-boy loneliness, take us away from that.' Of course, Frank had that quality of kind of drawing you in, and making you go along with him. Then, when he wasn't interested in you anymore, he was gone."

After Bogart's death in 1957, Bacall learned the lesson of Sinatra's mercurial charm when he began their courtship with a telephone call. " 'On Monday we're going to the Sugar Ray fight and on Friday we're going to this and on Monday we're going to that.' He took over. He decided that he was going to see me and I was going to be his girl. Then. At that moment," Bacall says. "I was thrilled." She continues: "He would be looking at you as if you were It. Then he'd be laughin' and jokin' and he walked off by himself. No one was gonna tie him down. I think one of the reasons that he and I split – it was his doing, not mine – was that he felt he never could live up to the kind of a man and husband Bogie was. He knew it would never work, because he'd be cheating on me in five minutes – because that's what he did. That's about the Swingin' Guy. That's about 'It's quarter to three, there's no one in the place except you and me.' "

Sinatra's womanizing ultimately threatened to undermine what success he still had. In the late forties, George Evans told Earl Wilson at the Copacabana, "Frank is through. A year from now you won't hear anything about him." He added, "You know how much I've talked to him about the girls. The public knows about the trouble with Nancy, and the other dames, and it doesn't like him anymore."

The siren that lured Sinatra onto the rocks was Ava Gardner, who was, like him, a card-carrying romantic narcissist – someone as self-absorbed, powerful, and impetuous as he was. ("When I lose my temper, honey, you can't find it anyplace," she wrote in her 1990 autobiography, *Ava: My Story*.) The public followed the melodrama of their passion as avidly as *Stella Dallas*. In her book, Gardner recalls Sinatra's coming over to her and

her first husband, Mickey Rooney, at a Los Angeles nightclub with his celebrity smile at full candlepower: "He did the big grin and said, 'Hey, why didn't I meet you before Mickey? Then I could have married you myself.'" She adds, "Oh, God, Frank Sinatra could be the sweetest, most charming man in the world when he was in the mood." And for a while he was. When they first got together, Gardner took him back to her little yellow house in Nichols Canyon. "Oh, God, it was magic," she wrote. "And God Almighty, things did happen."

Gardner was Sinatra's match in brazenness and in sexual independence. "Maybe people are paying too much attention to the 'lock' part of wedlock," the much-married Gardner said. Intimacy requires equality; in Gardner's high amperage, Sinatra had found it. "All my life, being a singer was the most important thing in the world," Sinatra told her. "Now you're all I want." Their relationship was tempestuous. "The problems were never in the bedroom," Gardner once said. "We were always great in bed. The trouble usually started on the way to the bidet." In New York, after a jealous argument, Sinatra called Gardner's adjacent suite. "I can't stand it anymore," he said. There was a gunshot. Gardner bolted into his room. Sinatra was lying facedown, the smoking revolver still in his hand. "Frank! Frank!" Gardner screamed. Sinatra looked up. "Oh, hello," he said. He had shot the mattress.

Their public affair finally destroyed Sinatra's marriage. On Valentine's Day of 1950, Nancy Sinatra petitioned for a legal separation. The press response was vitriolic. "You could always tell with him when he was troubled," George Evans said of Sinatra. "He came down with a bad throat. Germs were never the cause unless they were guilt germs." Shortly after the announcement of the separation, on April 26, at the Copacabana, Sinatra opened his mouth to sing and nothing came out. "I was never so panicked in my life," Sinatra said. "I remember looking at the audience, there was a blizzard outside, about seventy people in the place — and they knew something serious had happened. There was absolute silence — stunning, absolute silence." Sinatra's accompanist and conductor on that night, Skitch Henderson, recalled, "It became so quiet, so intensely quiet in the club — they were like watching a man walk off a cliff. His face chalk white, Frank gasped something that sounded like 'good night' into the mike and raced off the floor, leaving the audience stunned." Sinatra's throat had hemorrhaged, through stress and overwork.

("I didn't speak for forty days," he told Arlene Francis about his recovery. "For forty days I didn't say a single word.")

Sinatra married Gardner in 1951; they separated eleven months later. "I remember exactly when I made the decision to seek a divorce," Gardner wrote. "It was the day the phone rang and Frank was on the other end, announcing that he was in bed with another woman. And he made it plain that if he was going to be constantly accused of infidelity when he was innocent, there had to come a time when he'd decided he might as well be guilty." In the short time that they were husband and wife, though, Gardner, whose star was in the ascendant, did what she could to bolster Sinatra's falling star. Her ten-year contract with MGM contained a clause stipulating that "at some time prior to the expiration of her contract, we will do a picture with her in which Frank Sinatra will also appear." Although they never worked together, Gardner interceded on Sinatra's behalf with Columbia's president, Harry Cohn, to help her husband land the part of Maggio in *From Here to Eternity*, which he agreed to play for $8,000 instead of his usual $125,000. And Gardner, in her alcoholic, reclusive later years, was supported by Sinatra. Through their jealous rages, their sexual betrayals, and their reconciliations, Sinatra and Gardner were sensational public fodder; their private hell was memorialized by him in the outstanding "I'm a Fool to Want You," which he co-wrote and recorded in 1951, apparently so overcome with feeling that he did it in one take and left the session:

> *I'm a fool to want you*
> *I'm a fool to want you,*
> *To want a love that can't be true,*
> *A love that's there for others too. . . .*

In the meantime, Sinatra's ballads weren't selling. The public seemed indifferent to the old standards and avid for novelty. At Columbia Records, Mitch Miller, the most powerful producer of the day and the commercial wizard who found the mother lode of "Mule Train" and Frankie Laine, was trying to find a commercial avenue for Sinatra. Although Miller got Sinatra to do some up-tempo numbers, including the seminal "Birth of the Blues," in which Sinatra defines the swinging, hard-edged style of his middle years, he also persuaded Sinatra to record

"Tennessee Newsboy," with washboard accompaniment, and "Mama Will Bark," with the zaftig Dagmar and Donald Bain barking like a dog. ("The only good business it did was with dogs," Sinatra quipped, although the song got to number 21 on the charts.) These recordings represent the nadir of Sinatra's musical career, but they were also a barometer of Columbia's mismanagement and Sinatra's rudderless desperation. Miller was the donkey on whom Sinatra pinned the tail of his decline. "You cannot force anyone to do a song. People don't understand this," Miller told Will Friedwald in *Sinatra!: The Song Is You*. "Sinatra said I brought him all these shit songs, I forced him to do shit songs." Certainly, Sinatra disliked Miller's control-room intrusions into his music-making. "You don't tell the band what to do from the control room," Sinatra said to Miller at one session, as his regular drummer in those days, John Blowers, recounted to Friedwald. Blowers went on: "All of a sudden one day finally, quietly, he looked at the control room and said, 'Mitch, out' – and Frank always pointed his finger – and he said, 'Don't you ever come in. Don't you ever come into the studio when I'm recording again.' Mitch never came again. Frank wouldn't permit it, because he knew what he wanted." In Sinatra's final months at Columbia, his song selection seemed to be a message to his producer: "There's Something Missing," "Don't Ever Be Afraid to Go," and "Why Try to Change Me Now?" Years later, Miller caught up with Sinatra in Las Vegas, and went to shake his hand, seeking a kind of reconciliation. "Fuck you," Sinatra said. "Keep walking."

The losses piled up. In 1949, MGM let Sinatra go. In 1951, George Evans died, at the age of forty-eight. In 1952, *Meet Danny Wilson* flopped, and Universal refused to renew Sinatra's option for a second film; he was dropped by Columbia Records; CBS canceled *The Frank Sinatra Show*; and he was released by his theatrical agency. "I was in trouble. I was busted, and I must say that I lost a great deal of faith in human nature because a lot of friends I had in those days disappeared," Sinatra recalled at his Yale lecture. "I did lie down for a while and had some large bar bills for about a year." Then he explained, "I said, 'Okay, holiday's over, Charlie. Let's go back to work.' "

But who would hire him? When his new agent, Sam Weisbrod, called Alan Livingston, the A&R (artists and repertoire) man at Capitol Records, and asked if he would sign up Sinatra, Livingston said yes. "You would?" Weisbrod replied. The question mark spoke volumes. Livingston

explains, "I'm quoting him verbatim. I said, 'Yes.' He said, 'You would?' I mean, for an agent to react that way!" In 1953, Livingston, who later signed the Band and the Beatles, signed Sinatra to a one-year contract with six one-year options and a 5 percent royalty. "Frank Sinatra was totally down and out. I mean he was gone. In addition, his voice was kind of gone," Livingston says. "At the time I signed Frank, we had our national sales meeting. There were around a hundred and fifty salesmen, branch managers, regional managers there. I would play them upcoming records. I'd tell them about new artists. I said, 'I want to tell you this: we've just signed Frank Sinatra.' The whole place went 'Ooh' – like 'Oh, God, what are you doing to us?' They were just so unhappy about it." Livingston adds, "I remember my response. I said, 'Look, he's the greatest singer I've ever heard. He's in trouble, and he hasn't done anything for a long time. All I know how to deal with in my job is talent. This is talent.'"

At Capitol, Sinatra began to pull out of his skid. His songs seemed to announce it. On April 30, 1953, teamed with a brilliant new thirty-two-year-old arranger, Nelson Riddle, whom Livingston had suggested, Sinatra cut "I've Got the World on a String" and "Don't Worry 'Bout Me." "Sinatra was elated by the sound," Ed O'Brien and Robert Wilson write in *Sinatra 101: The 101 Best Recordings and the Stories Behind Them*. "During the playbacks that evening, Sinatra made the rounds in the studio, gleefully slapping the backs of musicians and technicians, and telling many of them that he was back."

Then, in August, *From Here to Eternity* was released, and Sinatra was reborn for sure. "By getting stomped to death in that movie, he did a public penance for all the wrongs he had done," Mitch Miller told Friedwald. "You can chart it. From the day the movie came out, his records began to sell." Sinatra was thirty-eight when he received the Academy Award for Best Supporting Actor in the film. Three months before he won his Academy Award in March 1954, Sinatra had begun psychotherapy; a week after his victory, he gave it up. "I found out all I needed to know," he said. Instead, he took up permanent residence in his success. "Before *Eternity*, nobody showed up," Frank Military said, referring to the Riviera Club in Fort Lee, New Jersey, which Sinatra had played the previous year. "Nobody even came to the dressing room to

congratulate him. I said, 'Where are all the people?' He said, 'These people only come out for stars and I'm through with them!'" Military continued: "The following year, *Eternity* comes out. We go back to the Riviera, and you can't get into the dressing room! I said, 'Frank, you said you were never talking to these people.' He said, 'There are no other kind of people!' " By 1954, the Sinatra-Riddle partnership had also produced the first hit single Sinatra had made for seven years, "Young at Heart," which went to number 2 on the charts.

Sinatra now had a public history of troubles and new triumphs to take on the road, and his songs were increasingly viewed by his audience and by him as a kind of autobiography: "All or Nothing at All" – the gamble on his talent; "I'm a Fool to Want You" – unrequited love of Ava; and now, in "I've Got the World on a String" – his comeback. But the new Sinatra was not the gentle boy balladeer of the forties. Fragility had gone from his voice, to be replaced by a virile adult's sense of happiness and hurt. "It was Ava who did that, who taught him how to sing a torch song," Nelson Riddle said. "That's how he learned. She was the greatest love of his life and he lost her." Sinatra's sound had acquired the edge that comes with suffering: something gallant, raffish, and knowing. "You have to scrape bottom to appreciate life and start living again," he said during his Dark Ages. In the forties, Sinatra's vocal experiments had to do primarily with smoothness; in the fifties, he discovered syncopation, and the new swagger of his voice broadcast the cocky sense of possibility that was America's mood as well as his own. In "Taking a Chance on Love," which he recorded on April 19, 1954, he sang:

> *Now I prove again*
> *That I can make life move again*
> Mmm – *I'm in a groove again*
> *Takin' a chance on love.*

The phenomenon of Sinatra as a crooner and playboy had somewhat obscured the public perception of him as a musician. But the Sinatra-Riddle collaboration changed that, and showed off Sinatra's musicianship to sensational advantage. Riddle's arrangements, which were not overly busy, left room for Sinatra's voice and for him to act his new part as Swinger. "The man himself somehow draws everything out of you,"

Riddle told Jonathan Schwartz on WNEW in the early eighties. "And I always felt that my rather placid disposition had a beneficial effect on him. He felt for some reason that the world was out to get him and he was gonna show 'em. I don't think he ever stopped that."

Together, they created the classic Sinatra sound – as luck would have it, just when sound technology produced both high fidelity and the long-playing record. "Never before had there been an opportunity for a popular singer to express emotions at an extended length," Schwartz says. As many as sixteen songs could be held by the twelve-inch LP, and this allowed Sinatra to use song in a novelistic way, turning each track into a kind of short story, which built and counterpointed moods to illuminate a larger theme. In their seminal LPs – *In the Wee Small Hours, Sinatra Sings for Only the Lonely, Songs for Swingin' Lovers!* and *A Swingin' Affair!* – Sinatra and Riddle came up with the first concept albums. Between May 1957 and May 1966, Sinatra had no Billboard Top Ten singles, but he had twenty Top Ten albums. Only the Lonely, which came out in 1958, stayed on the charts for 120 weeks; the 1959 follow-up album, *Come Dance with Me*, remained for 140 weeks.

From his earliest Dorsey days, Sinatra had understood the importance of arrangers. (When he left Dorsey, he took Axel Stordahl, who was Dorsey's arranger, with him, raising Stordahl's pay from $130 to $650 a week.) "I think as a class of people he had, and has, more respect for arrangers than anybody, including songwriters," Saul Chaplin says. He adds: "Frank learned how to adapt an orchestration from Dorsey. When the arranger would run down the orchestration, he would hear where the figures were, and when he sang the song he would arrange to clear it so those figures came through. He'd drop a note which he could have held because he knew the over-all is what counts, not just his voice alone." In performance, Sinatra often honored this musical division of labor by announcing the arranger and the songwriter of a number before he sang it. With Riddle, he was patient and precise about what he wanted. "When you hear a Frank Sinatra album, it's the product of Frank Sinatra's head," Riddle told Schwartz. The arrangement of "I've Got You Under My Skin," for example – which was so innovative that the session musicians applauded it the first time they played it through – was the result of lengthy discussion with Sinatra about the *Songs for Swingin' Lovers!* album. "He was always very coherent about what he wanted – where the

crescendi should take place, where the diminuendos, the tempi, naturally the key," Riddle said. "Sometimes it became almost painful in discussing an album of twelve or fourteen songs. It was a very precise, tense atmosphere. I would practically blow my stack because we'd take almost an hour on each piece. Then human nature would set in after five or six or seven or eight of those. He'd get tired. He'd say, 'Do what you want with the rest.' That would be the end of the thing, and we were both, I think, somewhat relieved."

The result Riddle achieved in "I've Got You Under My Skin" was, he said, "a sort of a cornerstone recording for both him and me." In their six-year partnership, Riddle moved from the influence of Ravel and Debussy to a more personal, biting, dissonant language. "I learned a lot from Frank about conducting for a vocalist," Riddle said. "I learned the importance of tempos, which are as important as the colorations in the orchestra." He added, "I learned to have an orchestra breathe with him phrase by phrase." Sinatra himself had learned the importance of tempo from Dorsey. "I used to watch Dorsey take eight bars of music, play it half a second faster for eight bars, and he says, 'Nail it right there,' " says Saul Chaplin, speaking of what in the pop vernacular is called "the pocket." "He once said, 'Every song has a correct tempo.' That doesn't mean it won't work at other tempos. It will, but there's only one at which it's best. Frank found the importance of that."

In "I've Got You Under My Skin," Riddle starts with a comfortable, loping rhythm that he called "the heartbeat rhythm" – "Sinatra's tempo is the tempo of the heartbeat," he said – and then created a marvelous instrumental tension around Sinatra's voice. Riddle always found little licks – certain spicy, nearly out-of-key notes – that would tease the key, and added the glue of "sustaining strings" almost subliminally to the rhythm and woodwind sections. At the instrumental breaks in the songs, Riddle gave solo voices to oboes, muted trumpets, piccolos, bassoons; in "I've Got You Under My Skin," it was Milt Bernhart's trombone, which whipped up the excitement until Sinatra joined the song again and brought it back to the heartbeat rhythm where it had begun. Sinatra had wanted an extended crescendo; Riddle provided one that was longer than had ever been heard in an organized arrangement.

The song won a fans' poll as the all-time-favorite Sinatra recording; it "changed American popular music, and that is not overstating the case,"

Schwartz says. "Nothing was the same after that specific arrangement and also the sound of the *Songs for Swingin' Lovers!* album itself." Sinatra had found his groove. His singing in this period was more than a sound; it was an attitude. He gave us words, postures, rhythms – a sense that sex and life were going to be a big "wowie," as he sang in "Me and My Shadow." The postwar party had begun; and while the fifties were stalled in normalcy, Sinatra had about him a whiff of the libertine. His style – the thin, sensitive line of his look and of his singing – had the immanence of the hip combined with the articulateness of the traditional, to which all of us preppy white boys could relate. We dressed Sinatra, doing up our paisley Brooks Brothers ties into Windsor knots. We talked Sinatra: "Charlies" for breasts, "gas" for fun, "bird" for pecker, the suffix "-ville" added to as many words as we could work into our new patter. We wanted to go to the party, and it seemed that Sinatra had always been there.

After the humiliations of his decline, nothing so moved Sinatra as the spectacle of himself as a powerhouse: big talent, big guys around him, big bucks behind him, big connections to the mainstream and to underworld power. "He used his success in film, in singing, and in business to pump up the persona of untouchable," Tony Curtis says. "Notice I don't bring up the Mafia. He in himself was his own godfather. He ran his own family and his friends like that. Untouchable." Over the decades, this omnipotent impulse has, if anything, become more pronounced. "Frank loved to end, then leave town like a modern-day Roman warrior," Shirley MacLaine writes of touring with him in 1992. "He insisted on a police escort (even at four in the morning on empty streets) with flashing lights and cops on motorcycles leading the way."

Before his comeback, Sinatra had survived hand-to-mouth, primarily on borrowed money; after it, he laid the groundwork for an empire. Sinatra, who lived in Beverly Hills but who once kept homes in New York and London as well, ruled over his kingdom in his heyday primarily from his compound in Rancho Mirage, California, which grew over the years – until it was sold, in 1995 – into a kind of metaphor of his aggrandizement, with a helipad, a swimming pool, tennis courts, a screening room, and a state-of-the-art kitchen with full twenty-four-hour service. The compound also boasted two two-bedroom guest houses, each with his-and-hers bathrooms and, in "The Kennedy

Room," a red White House hot-line telephone that was originally installed for an aborted visit by JFK in 1962. (Much to Sinatra's rage, the president, on orders from Bobby Kennedy to distance himself from Sinatra and his Mafia connections, stayed instead with Bing Crosby in nearby Palm Desert.)

"Frank destroys money," Joe DiMaggio said of his friend; Sinatra's lavish entertaining bespoke not just a man of talent but a man of property. (Sinatra's fortune was estimated at $200 million in 1997.) Sinatra owned 9 percent of the Sands Hotel in Las Vegas, which he turned almost single-handedly into an entertainment mecca. (He became vice president of the corporation, and earned $100,000 for each week he performed, until falling out with the hotel in 1967.) For a time in the sixties, he also owned 50 percent of the Cal-Neva Lodge in Lake Tahoe. In those days, buttons began to appear with Sinatra's face on them, bearing the motto IT'S SINATRA'S WORLD, WE JUST LIVE IN IT. And so it seemed. Sinatra also acquired large interests in a small charter airline, a missile-parts company, a music-publishing house, radio stations, restaurants, and real estate; at one time in the sixties he employed a staff of about a hundred. He formed Essex Productions and received as part of his fee 25 percent of *Pal Joey*; another Sinatra company received the same percentage for *The Joker Is Wild*, in which he starred.

By the end of the decade, Sinatra had earned so much money for Capitol that he wanted his own label. He proposed a fifty-fifty split with Capitol, who would distribute – a deal that was unheard of in those days but is common now. When Capitol refused, Sinatra formed his own record company, Reprise Records; he pronounced it with a long "i," as in "reprisal." "Fuck you! Fuck your company!" Sinatra shouted over the phone to Capitol's Alan Livingston when Livingston tried to reach a last-minute agreement with him. Livingston recalls, "Frank said, 'I'm going to destroy that round building. I'll tear it down.' " Although Sinatra was forced to make four more albums for Capitol, Capitol continued after he was gone to make Sinatra albums from unreleased recordings and sell them at cut prices. "The market was flooded with our Sinatra albums," Livingston says. "Reprise got killed. Nobody was taking their product. Then Jack Warner came in and bailed Sinatra out." (Sinatra sold two thirds of Reprise to Warner Bros. in 1963, for more than three million dollars' capital gain.)

Onstage, Sinatra was in control of his world and beyond hurt. Offstage, he was fearful and somewhat paranoid. "To Frank, the outside environment was fraught with danger from press people," Tony Curtis says. His paternal advice to Nancy was "Be aware. Be aware of everything around you." Wealth brought Sinatra a liberating sense of control over life. "I remember we were on a plane flying from Las Vegas to Palm Springs," Aileen Mehle says of a trip she took with Sinatra in the early sixties. "He had paper bags full of, I think, hundred-dollar bills. Loaded. Hundreds of thousands. He upended the bags in the middle of the plane and started throwing the money up in the air. Talk about playful! He said, 'I'm celebrating, because for the first time I have a million dollars cash in the bank that I don't give a damn what I'm going to do with.' "

Among his friends, Sinatra has always been known for impulsive, awesome acts of generosity – those grand gestures that Sicilians call *la bella figura*. "I always felt I could call and say, 'Frank, I'm in trouble. I need a hundred thousand dollars,' " Jo Stafford says. Sinatra picked up some of Lee J. Cobb's hospital bills after the actor's 1955 heart attack. He also found him a deluxe apartment in which to recuperate. He bought his pianist Bill Miller a new home and wardrobe after his house was washed away and his wife killed in a mudslide. He sent his friend the actor George Raft, who was under indictment for federal-income-tax evasion, a signed blank check with a note saying, "To use if you need it." When Phil Silvers's partner Rags Ragland died just before they were to open the Copacabana, in 1946, Sinatra flew across the country to surprise the comedian and play straight man. "To this day Frank doesn't know how to express affection," the late Phil Silvers said in the fifties. "He does it with expensive presents." Chartered yachts, planes, hotel tabs, hospital bills, extraordinary presents (a five-thousand-dollar Ramirez guitar for his guitarist Al Viola; an antique wooden flute for Tony Curtis, who had taken up the instrument while shooting *Sweet Smell of Success* – "It wasn't my birthday or nothin'," Curtis says). "When someone was down on his luck, Frank was like the Marines. He was there," I was told by the late actress-turned-psychotherapist Ruth Conte, the former wife of the actor Richard (Nick) Conte, who was part of Sinatra's circle in the fifties. "When Nick left me, Frank called me. 'How ya doin', baby.' A kindness that was also an assertion of power. It was so reassuring to him to be able to use it."

Indeed, Sinatra's compulsion to assuage his friends' anxieties was a way of keeping his own at bay. "You sometimes felt you want to run away from him," Burt Lancaster said. "Because if you say to Frank, 'I'm having a problem,' it becomes his problem. And sometimes maybe you'd like to try and work it out yourself." Sinatra's need to protect made him an extraordinary but contradictory friend. "When he's good, he's very, very good, like the wretched little girl," Leonora Hornblow says. "He cares about you. He wishes you well. If things are not well, he wants to make them all right. You are enveloped by warmth." To Sinatra, who cannot easily say "I'm sorry" or admit wrong, generosity and omnipotence were linked. Inevitably, he had trouble acknowledging the generosity of his friends and colleagues. "He just isn't built to give out compliments," Nelson Riddle has said of him. After Sinatra got an Academy Award, he said, "I did it all myself." This separation of himself from others, which accounts for his arrogance, also accounts for the special quality of loneliness in his singing. "He understood loneliness better than any other person of his generation," Pete Hamill says. "I mean a certain kind of urban loneliness." But what Sinatra evokes is not strictly urban. It is a very particular American loneliness – that of the soul adrift in its pursuit of the destiny of "me," and thrown back onto the solitude of its own restless heart. Once, in a shouting match with a press agent who had the temerity to suggest that Sinatra was dependent on the public, Sinatra shot back, "I am not! I have talent and I am dependent only on myself!" The autonomy of Sinatra's power was central to his behavior. "If you helped him more than he helped you, the friendship was doomed because the balance he wanted had been tipped," Shirley MacLaine writes. "And if you worked for Frank and attempted to protect him from himself, you committed the most heinous of all crimes." She adds, "He was a happy man when he was able to come to my rescue. 'Oh, I just wish someone would try to hurt you so I could kill them for you,' he'd say."

As a singer, of course, Sinatra could be all-giving and all-conquering all the time. The cocked hat, the open collar, the backward glance with the raincoat slung over the shoulder, the body leaning back with arms wide open in song – these images of perfect individualism dominated the albums of the fifties. Sinatra was flying high. "Come fly with me! / Let's fly! / Let's fly away!" he commanded the world. But these

lyrics also hint at Sinatra's escape into success – into an empyrean where no one could touch or judge him: "Up there! Where the air is rarefied / We'll just glide, starry-eyed." Momentum was always Sinatra's antidote to anxiety; now he resumed his destiny in motion. "No one seems to be able to help me with it – doctors, no one," Sinatra told the late movie director Vincente Minnelli about his reckless pace. His life pattern was set. ("After dinner and enough Jack Daniel's, Frank was likely to suddenly decide not to go home, but to Las Vegas instead, or Miami, or New York," Mia Farrow writes. "He would feel the pull of that other world – the third part of his life – and it would be pointless to object.") Working, womanizing, crisscrossing the globe in his private plane, Sinatra, who hated to waste time, now devoted his life to trying to kill it. "To beat time all the time, to beat time at its own game," his daughter Nancy says. Sinatra retreated into his own deluxe and contradictory isolation – he was an insomniac who needed people around him at all times. Instead of intimacy, he offered his audience bits of his legendary public story. Some of his songs invoked his family ("Tina," "Nancy with the Laughing Face"); in "Me and My Shadow" he referred to his saloon-keeping *philosophes* Jilly Rizzo and Toots Shor. Sinatra stood before an audience as a person who had caroused with killers and kings. He'd been married to the most beautiful woman in the world. He had won and lost and now won again. All this made him more interesting as a performer than anything he sang. Sinatra's best songs of the period – "All the Way," "Call Me Irresponsible," and especially "Come Fly with Me" – were written by Sammy Cahn, who had roomed with Sinatra, traveled with Sinatra, and lived a lot of Sinatra's story with him. The material *was* Sinatra. "Sammy's words fit my mouth the best," he told the producer George Schlatter.

With subtler lyrics, Sinatra's interpolations could sometimes smudge the word picture and, incidentally, infuriate the lyricists. "Ira Gershwin hated that Sinatra took 'A Foggy Day' and sang 'I viewed the morning with much alarm,' " the singer Michael Feinstein, who was for a long time Gershwin's assistant, says. "The lyric is 'I viewed the morning with alarm.' It drove him crazy, because he felt the word 'much' weakened what he originally wrote." And it did: lyrics, like everything else, could suffer from Sinatra's egotism. Leonora Hornblow tells of an evening at actor Clifton Webb's when Cole Porter was also present: "Frank fiddled with the lyrics. I think it was 'I Get a Kick Out of You' – you know, 'You

give me a boot.' Cole got up and walked out. Cole had perfect manners. For him to do that while somebody was singing was like stripping his clothes off." Sinatra revered Porter (he leased Porter's apartment at the Waldorf Towers), but he also thought Porter "a snob," whereas Cahn wrote lyrics that had Sinatra's common touch. "Anybody hits you, call me," Sinatra scribbled on a note to Cahn in 1990. Cahn spoke and wrote in the same demotic, tough-talking, breezy manner ("Hey there, cutes, put on your Basie boots"). "Sammy saw himself as Frank," his widow, Tita Cahn, says. "Frank without the voice, without the looks." Cahn had the same instincts about a song as Sinatra. "Sammy always showed Frank the song and phrased the song for him," Frank Military says. Cahn knew Sinatra's moves; sometimes, even, Cahn's moves became Sinatra's. "Sammy was appearing in San Francisco," Tita Cahn says, of Cahn's successful one-man show of his hits. "I went backstage. I said, 'Sammy, you know there's so much of Frank in you when you sing. You know when you lean back? Is that from hanging around Frank so often? From watching him so often?' " Tita Cahn continues: "There was a beat. Sammy did a take, and he said, 'Who sings the songs first, the singer or the songwriter?' "

"There are three questions which have no answer," Sammy Cahn used to say. "Where is Frank? How is Frank? Do you think Frank'll show here tonight? That's all the world wants to know." In the fifties, Cahn played a large part in building the image of the loosey-goosey, unpredictable ring-a-ding guy. He and the composer Jimmy Van Heusen were commissioned by Sinatra to write a song using Sinatra's catchphrase for his first Reprise album, which was called, not surprisingly, *Ring-a-Ding-Ding!* The phrase – like Shakespeare's "Hey nonny nonny" – thumbed its nose at meanings and sincerity. Sinatra's songs of this period – the late fifties and early sixties – however beautifully rendered, don't express the truth of his hurt or the exhilaration of his innocence. "Ring-a-Ding-Ding!," for instance, is a slick piece of emotional coasting. It substitutes pop romance for Sinatra's real-life, boozy, orgiastic refusal to suffer:

> *Life is dull, it's nothing but one big lull,*
> *Then presto! You "do a skull" and find that you're reeling,*
> *She sighs, and you're feeling like a toy on a string,*
> *And your heart goes ring-a-ding-ding! Ring-a-ding-ding!*

Drink played a large part in Sinatra's ring-a-ding arrogance. "Frank Sinatra is, in the most dramatic and classical sense, an alcoholic," Jonathan Schwartz says. "There's a grandiosity, a fury, a self-pity, a night viciousness." He adds, "He made drinking an asset. He made it romantic." (Sinatra was given an acre of Tennessee land by the Jack Daniel's distillery for being what amounted to a one-man ad campaign for their sour mash.) In the fifties, foreshadowing the performing indulgences of the sixties, Sinatra began bringing a tumbler of Scotch and a pack of cigarettes onstage. "Nobody'd ever done that before, had they?" the author and renowned teacher of dramatic singing David Craig says. "Abusing himself like no singer in history." It was another way for Sinatra to flaunt his invincibility. "He's trying to demean his gift," Tony Curtis says. "He just wants to show you – like a juggler or a guy who works the tightrope, he goes up there with a drink in his hand and a cigarette butt – that he can still do it."

"If you can use some exotic booze / There's a bar in far Bombay," Cahn wrote memorably in "Come Fly with Me"; he also provided the Rat Pack with an ensemble hymn to the sauce, "Mr. Booze," in the movie *Robin and the Seven Hoods*. Cahn had Sinatra's number. Once, enlisted by Sinatra to be the "idiot card" when Sinatra played the Empire Room at the Waldorf Astoria in the fifties, Cahn sat at a ringside table. At one point, Cahn turned away to relax his neck. "Frank kicked me in the ankle and said 'Pay attention,' " Cahn writes in *I Should Care*. "Not so sweet, but nobody ever said Sinatra was all anything – including heart." Even in such matters, Cahn found a discreet way of turning Sinatra's quixotic lapses to public advantage. "Call me irresponsible," he wrote. "Call me unreliable, / Throw in undependable too." He understood Sinatra's bad behavior was romantic in song; in life, Cahn saw it differently. Tita Cahn recalls, "Sammy used to say that Frank was a man who kept putting the dream to the test, pushing it too far, hoping that someone would hit him and he'd be awakened. But nobody did. The dream wouldn't go away."

"Frank created this romantic figure he wanted to be," Lauren Bacall says. "There was something about him that was a little unreal. I think he fantasized a bit." She continues, "He was away singing at some club, and he would call me and say, 'I'm coming home tonight. I want you to be at the house when I get there.' I – jerk – thought, How glamorous. I'd get in my car, drive up to his house. I'd be standing there by myself, then

suddenly *in he'd walk*. Oh, God, what a great moment! Then just as easily that night he could throw me out. He was capable of that kind of change." When news of Sinatra's engagement to Bacall was leaked to the press by her agent and Sinatra's friend Swifty Lazar in 1958, Sinatra immediately dropped her. Years later, when he was seeing Mia Farrow, Bacall met him and chatted warmly with him at a party given by Lazar. "Frank never mentioned to me that he knew that Lazar had been responsible for the press, never said a word to me about it," Bacall says. "Swifty was sitting at another table across the room. Before Sinatra left, he got up and walked over to Lazar's table. He put his hands on the tablecloth and pulled the fucking tablecloth off the table – all the glasses, the plates, everything fell on the floor. He said, 'And you're the one who's responsible for what happened between us!' He turned around and walked out."

At the time of his marriage to Barbara Blakeley Marx, after a pre-wedding dinner in Palm Springs, a photographer made the mistake of poking his camera at the windshield of a car in which Sinatra was at the wheel. Tina Sinatra was in the backseat with Judy Green, a close friend of the family. "I remember grabbing Judy's arm and she grabbed mine. I was afraid he was going to run him over," Tina Sinatra says. "Dad didn't run him over. That was the good news. He jumped out of the car, grabbed the guy's camera, takes the film, throws it in the backseat right between me and Judy. By now, he's slammed his door, we're locked in, we're gone. Nobody says a word. Judy – she's a photography nut – she leans close to me. 'Can you hear me? He got the battery, not the film.' " Tina Sinatra continues: "I looked at her and I said, 'I'm not gonna tell him. Are you?' She said, 'No.' So the pictures were published."

Sinatra, whom Peter Lawford called "the lovable land mine," was at once cursed and blessed by this notoriously thin skin. His hypersensitivity made him both hell on a short fuse and more sensitive to emotion in a lyric. "He's a passionate man," Shirley MacLaine says of Sinatra's "wide emotional landscape." "Passions are sometimes greater than his ability to control them. If something really bothers him, that takes over." Sinatra seemed compelled to discharge any unsettling feeling as quickly as possible. "It's not something I do deliberately. I can't help myself," Sinatra told *Playboy* in 1963. "If the song is a lament about the loss of love, I get an ache in my gut. I feel the loss and I cry out the loneliness." He went on: "Being an eighteen-karat manic-depressive and having lived a life of

violent emotional contradictions, I have an overactive capacity for sadness as well as elation." Song, like rage, had the ability to put Sinatra "beside himself"; and, like song, his fury served as a kind of antidepressant. "He never gave you the reality," Tony Curtis says of Sinatra's singing persona. "I saw dissatisfaction, an anger, a frustration from that immigrant background of his." Song transformed Sinatra's aggression into joy. "Singing is like a lightning rod, particularly when he was in good voice," his Capitol producer Dave Cavanaugh said. "It discharged the hostile electricity."

When Sinatra's combativeness first surfaced, in the forties, the press found it amusing. The joke was that Sinatra's famously padded shoulders were full of chips. At the Waldorf, he stopped his show and asked a heckler to step outside. DON'T SAY SINATRA STINKS UNLESS YOU CAN PUNCH, headlined *Down Beat*. Even before that, Sinatra had tapped out Tommy Dorsey for an anti-Semitic remark; leapt into the audience to fight paying customers who were throwing popcorn at Jo Stafford; thrown a water pitcher so hard at drummer Buddy Rich that glass was stuck in the wall. A sense of danger always surrounded Sinatra and his music. Sinatra knew it, and made the climate of menace work for him. Once, at a London restaurant, Sinatra asked the owner if he could buy some of the red glass pieces that decorated the place for his friend Leonora Hornblow, who had begun collecting the same kind. "He said, 'Mr. Sinatra, you can have *anything*, but we collect the red glass. The room is built around the red glass,' " Leonora Hornblow recalls. "Frank said, 'You didn't hear me. I want to buy some of the red glass for Mrs. Hornblow. But if you won't sell it to me, I'll take it. And you know I will.' " They sold Sinatra some of the glass.

A gray area almost always surrounded the incidents of Sinatra's reported violence. During the first Capitol recording session in 1953, Alan Livingston sat with Sinatra virtually alone at Lucy's, a bar on Melrose Avenue in Los Angeles. Livingston was trying to talk Sinatra into cleaning up his tough guy act. "Sinatra said, 'I don't do anything. I don't do anything,' " Livingston recalls. "A guy at the end of the bar looked at us and said, 'What are you doin', Frank? Buyin' a drink for your leech friend?' Frank says, 'See, I didn't do anything?' Frank said to the guy, 'Knock it off.' The guy said, 'Knock it off. Knock it off! Big guy!' Frank's piano player and bodyguard Hank Sanicola grabbed this guy and threw

him bodily out of Lucy's. Frank says, 'See, I didn't do anything.' " Sinatra exuded an aura of bumptiousness, which some of his friends found droll. "He is a kind of Don Quixote, tilting at windmills, fighting people who don't want to fight," Humphrey Bogart said. Bogart found Sinatra's pugnacity "very funny." "He's just amusing because he's a skinny little bastard and his bones kind of rattle together." He brought the same attitude to song. "There's this thing in Sinatra that sort of demands that you respect what he does, or you'll get your ass kicked," Pete Hamill says. Even backstage in Las Vegas, when Sinatra walked off after a successful gig, Tony Curtis noticed that Sinatra's face "was drawn and ready for a fight." Curtis says, "When he got up onstage, he seemed to say, 'Fuck you, motherfuckers. Sit quiet. I'll show you something.' That was part of the kick."

"That façade of being macho and strong grew as his career grew," says Nancy Sinatra, Sr. "He became part of that image. He was never quite that at all, believe me." But Sinatra was pleased with his reputation for toughness. When Al Capp mythologized him as Danny Tempest in the cartoon strip *Li'l Abner*, Sinatra thanked him. When Sinatra spoke out against racial prejudice, he was the voice of almost-sweet reason. "When somebody called me a 'dirty little guinea,' there was only one thing to do – break his head," Sinatra said, of growing up in his tough Hoboken neighborhood. "When I got older, I realized you shouldn't do it that way. I realized you've got to do it through education – maybe with a few exceptions." Sinatra was certainly not built for the tough-guy persona that grew up around him. "He couldn't hit his way out of a paper bag," Lauren Bacall says. "So he would get into this big verbal fight. Somebody would hold him back and Jilly would punch somebody out. He always had one of those guys with him." Sinatra joked about such incidents. "He became punched" is how he put it. A gold plaque on one of the gates to his Palm Springs enclosure called attention to the owner's notorious temper:

NEVER MIND THE DOG
BEWARE OF THE OWNER

Sinatra's rage-outs were no laughing matter; it says something about the power of his talent that his career wasn't ruined by such behavior. But

it wasn't; it only added to the contradictions of light and dark that made him legendary. Denial was one way the Rat Pack dealt with Sinatra's outrageousness. "The King can do no wrong" was their motto. "I did everything I could to avoid setting off that temper," said Peter Lawford, who once saw a juiced-up Sinatra throw a girl through a plate-glass window during a Palm Springs party. In time, Lawford went from being a beloved member of the Rat Pack to a rat, in Sinatra's eyes; his response to Sinatra's violence changed from insouciance to irony. "You might get the impression that the gentleman in question was a total ogre," Peter Lawford is quoted in *The Peter Lawford Story*. "Far from it. I mean, just because he punched a few defenseless girls, broke a few cameras of news photographers in the line of duty, instigated the roughing up of a couple of parking lot attendants who were guilty of that unpardonable faux pas in the world of status, that his car wasn't first in line outside the old Romanoff's Restaurant, or probably the most infamous of all, by having one of his illiterate but blindly loyal goons bury a six-inch glass ashtray in the head of a man sitting next to him in the Polo Lounge of the Beverly Hills Hotel, whom he happened to overhear make a mildly derogatory remark about him. . . . So you can plainly see, he's not all bad."

Often at issue in Sinatra's blowups was a real or imagined humiliation. "When he thought he'd been insulted, he was like a wild man," the singer Eddie Fisher said. Sinatra's way of dealing with insult was often to turn humiliation back on the perpetrators. Sinatra met up at Chasen's with Mario Puzo, whose novel *The Godfather* contained the fictional character Johnny Fontane, which impugned Sinatra's reputation by conflating in the popular imagination Sinatra's winning the role in *From Here to Eternity* with Mafia influence. Sinatra shouted Puzo out of the restaurant. "Choke, go ahead and choke, you pimp!" Sinatra yelled as Puzo walked out. Once, seeing the gossip columnist Dorothy Kilgallen sitting at a nightclub banquette in sunglasses, Sinatra dropped a dollar bill in her glass. "I always thought you were blind," he said. He upped the ante in 1973, when *The Washington Post*'s Maxine Cheshire approached him as he got out of Ronald Reagan's limousine on his way to a governor's dinner at the State Department hosted by Sinatra's friend Vice President Spiro Agnew. "Mr. Sinatra, do you think that your alleged association with the Mafia will prove to be the same kind of embarrassment to Vice President Agnew as it was to the Kennedy administration?" she asked. Sinatra, who

answered politely at the time, remembered the provocative question – which Cheshire had been primed by her editor to ask – and a few months later, when he encountered her again at a preinaugural party talking to his wife, he returned Cheshire's humiliation in kind. "Get away from me, you scum," he said. "Go home and take a bath. Print that, Miss Cheshire!" Then he turned to the people around him. "You know Miss Cheshire, don't you? That stench you smell is coming from her." Sinatra turned back to her. "You're nothing but a two-dollar cunt. C-u-n-t, know what that means? You've been laying down for two dollars all your life," Sinatra said, putting two dollars in the plastic cup she was holding and then stalking out of the party with his wife in tow. The incident caused a local rumpus. (When Dolly Sinatra was asked by reporters for her opinion, she said, "Frank overpaid.") Sinatra never stopped using the stage as his bully pulpit to berate the press. When he'd sing "I Can't Get Started," which has the couplet "All the papers, where I led the news / With my capers, now will spread the news," at the word "papers" his face would go sour and he'd spit. He'd also rant at Barbara Walters ("the ugliest broad in television"), Rona Barrett ("What can you say about her that hasn't been said about . . . leprosy"), and Liz Smith ("so ugly she has to lie on an analyst's couch facedown"). This public picking at old wounds was an ugly part of Sinatra's act; but it had the salutary psychological effect on the old performing workhorse of keeping his passions high.

"He believes in punishment. He's a bully," says Jonathan Schwartz, who for more than a decade has played nothing but the Chairman of the Board on his *Sinatra Saturday* program, and was forced on a three-month "sabbatical" from WNEW after he called the final third of Sinatra's 1980 *Trilogy* album "a mess of narcissism." In "My Way," the anthem of Sinatra's later years, which Sinatra came to dislike, he sang, "The record shows I took the blows / And did it my way." Actually, the record shows that other people took the blows. In 1967, after his credit was stopped at the Sands in Vegas, Sinatra exacted retribution by signing a contract with Caesar's Palace and then going on a tear at the Sands: threatening dealers, driving a golf cart through a plate-glass window, breaking furniture and trying to set it alight, and finally confronting the executive vice president, Carl Cohen. "I'll bury you, you son-of-a-bitch motherfucker," he told Cohen, whereupon Cohen removed the caps from Sinatra's front teeth. (Sinatra later laughed it off. "Never punch a Jew in the desert," he said.)

"I think the rage might have been a double rage," Pete Hamill says of Sinatra's wild outbursts. "A rage against the object of his anger and a rage against himself in some way, for losing his temper and letting this classy façade crumble so easily."

As Sinatra's power grew over the years and he became a kind of law unto himself, he dealt with conflict by withdrawing the favor of his presence and walking away from relationships. "You don't exist for me" is one of Sinatra's high-dudgeon dicta; and it's a true statement of how his imagination worked. After dropping Bacall, Sinatra encountered her by chance in Palm Springs. "He looked at me as if I were the wall. It was so terrifying. I have never had that experience before or since," she says. The late dancer Juliet Prowse called Shirley MacLaine after Sinatra broke off their engagement. "I just said I wanted him to meet my family in South Africa," Prowse said. "And he regarded that as a slight. He won't talk to me now." When Sinatra called Shirley MacLaine, he told her, "She [Prowse] doesn't really want to marry, babe. I don't need to pass muster with anybody." Friends were banished sometimes for a week, sometimes forever. Phil Silvers was cut off in the late fifties after CBS programmed *The Phil Silvers Show* opposite ABC's revamped *Frank Sinatra Show*. "You had to go Fridays, huh?" Sinatra said, and stopped speaking to Silvers for sixteen years. Peter Lawford bit the dust twice – initially when he was Ava Gardner's first date after her divorce from Sinatra. "He threatened to kill me and then didn't speak to me for five years," says Lawford, who was struck off again after the Kennedys' postelection snub of Sinatra's Palm Springs estate, simply because he was married to JFK's sister Patricia. In 1959, when Sammy Davis, Jr., complained about Sinatra to a Chicago journalist, saying, "I don't care if you are the most talented person in the world. It doesn't give you the right to step on people and treat them rotten," Davis spent a couple of months in purgatory, and was returned to the fold only after he offered a public apology for his outburst.

Sinatra's handsome butler of over a decade, George Jacobs, was not so lucky. Sinatra became jealous of Jacobs after a gossip column mentioned he'd danced at a Hollywood club with Mia Farrow the night before her divorce from Sinatra became official. When Jacobs returned to Palm Springs, Sinatra had locked himself in the bedroom and refused to speak to Jacobs, who was fired by a lawyer. "After fourteen years together he dropped the net on me just like that, and he couldn't even look me in

the face to do it," Jacobs told Kitty Kelley; he threw away all Sinatra's presents and sold his shares in Reprise Records. He went on, "I nursed him through his suicide attempts. . . . I helped him get through Ava. . . . I was even the nurse after his hair transplants. . . . I drove all the girls to their abortions, and I treated each one of those dames like a queen because that's what he wanted me to do. The women that man had over the years! I remember Lee Radziwill sneaking into his bedroom. How do I know? I heard her. I always had a room next to Frank so he could slap the wall for me if he needed anything."

The atmosphere of intimidation that surrounded Sinatra was reflected in the jokes of the Vegas comedians. Shecky Greene: "Frank Sinatra once saved my life. I was jumped by a bunch of guys in the parking lot and they were hitting me and beating me with blackjacks when Frank walked over and said, 'That's enough, boys.' " Don Rickles: "C'mon, Frank, be yourself. Hit somebody." Jackie Mason always avoided Sinatra, but he thinks he must have told some jokes about Mia Farrow while he was playing the Aladdin Hotel in the early eighties. Sinatra came onstage after Mason's set and began berating him. " 'The jerk-off rabbi.' 'Who the fuck is he?' This, that, 'fuck him,' " Mason says. "I don't even know what happened. All I know is that a couple of weeks later, I opened the door of a car – ping! – a fist came in and busted me in the nose and before I could open my eyes, he disappeared. I asked a lot of wiseguys. They didn't *say* it was Sinatra. In my heart of hearts, I think it must have come from Sinatra." Even if Sinatra's menace wasn't verifiable, it was part of his aura of power – a rough justice underlined by his friendship with punks and presidents.

The most powerful among Sinatra's powerful friends was, of course, John F. Kennedy, for whom he acted as both fund-raiser and pander. The fun-loving Kennedy, whom Sinatra nicknamed "Chicky Boy," enjoyed carousing with Sinatra's star-studded cronies; Sinatra repaid the honor of the association by calling his clique the Jack Pack, for a brief time, and even introduced Kennedy to one of his girlfriends, Judith Campbell, who would also become associated with Sam Giancana. Sinatra worked hard for the Kennedy campaign at various election stops, but more important, he worked behind the scenes. The 1960 presidential

election, which Kennedy won by only 118,500 out of over 68 million votes, was swung by the mob-controlled West Side of Chicago, whose support was mobilized through Sinatra's efforts. "Frank won Kennedy the election," Skinny D'Amato said. "All the guys knew it." Sinatra got to visit Hyannis Port, to travel in the president's private plane, and to cruise with the president on the *Honey Fitz*; he even escorted Jackie Kennedy, who didn't want him in the White House, to the inaugural gala he'd organized.

If Kennedy's high rank confirmed the brightness of Sinatra's star, the darkness of Sinatra's past was confirmed by the frequent presence of the wiseguys he was drawn to. Over the years, Sinatra rubbed shoulders with a gallery of hoodlums: Willie Moretti, Joe Fischetti, Lucky Luciano, Carlo Gambino, and especially Sam Giancana, who was the head of the Chicago mob in the fifties, and who called Sinatra "the Canary." Part of Sinatra's freewheeling impudence came from the wisdom of the underclass – the belief that crime was free enterprise turned upside down and that there was a slim difference between being a killer and making a killing. "If what you do is honest and you make it, you're a hero," Sinatra said. "If what you do is crooked and you make it, you're a bum. Me – I grabbed a song." Sinatra walked a thin line between respectability and rapacity. He had learned the manners of the ruling class, and he owned all their pleasures; what the mobsters offered him was the flip side – their lack of propriety. They lived the darkness that Sinatra's bright public persona could only hint at in song. "He was in awe of them," Lauren Bacall says. "He thought they were fabulous." She continues: "He always had one of those guys with him. I remember meeting Joe Fischetti. He was always introduced as 'Mr. Fish.' He used to stay with Frank when he came to L.A.; suddenly you realize, 'Hey, wait a minute, this guy, I think, maybe has killed someone. He's a real hood.' "

Onstage, where the association gave Sinatra an aroma of toughness and menace, he sometimes joked about the wiseguys; offstage, he was loath to talk. "He has this strange notion that nobody knows for sure that he really knows these people," Shirley MacLaine says. "I don't know why. I only know that Sam Giancana taught me how to play gin rummy when we were making *Some Came Running*." She goes on: "Everybody was there. There was a toy water pistol on top of the refrigerator. The doorbell would ring. I was sort of the butleresse. I would answer the door, bring in the cannolis or the chocolates or the flowers, whatever. Suddenly,

something flashed in my mind that I'd seen those hooded eyes before. I pulled out the water pistol, trained it on Giancana as a joke, and said, 'Haven't I seen you somewhere before?' Sam leapt to his feet and pulled a .38 pistol, a real one, out of a holster inside his jacket. Just at that moment, Dean Martin and Frank came in and fell over laughing. They told that story all over the world." When Hamill first raised the touchy issue of the mobsters with Sinatra, Sinatra said only, "If I talk about some of those other guys, someone might come knockin' at my fuckin' door." But he later went on, "I spent a lot of time working in saloons. . . . I was a kid. . . . They paid you, and the checks didn't bounce. I didn't meet any Nobel Prize winners in saloons. But if Francis of Assisi was a singer and worked in saloons, he would've met the same guys."

A nineteen-page Justice Department memorandum prepared in 1962 suggests that Sinatra had contact with about ten major hoodlums, some of whom had his unlisted number. As a result, Sinatra has become, in Pete Hamill's words, "the most investigated American performer since John Wilkes Booth." The press wanted to see corruption in Sinatra's connection to the Mob, although none has ever been proved; in any case, it's not cash but comfort that the Mob really offered Sinatra. In the company of these violent men, he was not judged for his own violent nature; in the context of their ignorance, his lack of education didn't matter. He could drop the carapace of sophistication and embrace his shadow.

The epigraph to one of his daughter's books about him quotes Sinatra as saying, "Maybe there might be value to a firefly, or an instant-long Roman candle." Sinatra's voice, as he well knows, put a lasting glow on six decades of American life and three generations of fans. Sinatra stumped for FDR, who invited him to the White House; he was still around to sing at the inaugural gala of Ronald and Nancy Reagan. His was a voice for all political seasons. In the forties, with "The Song Is You," "All or Nothing at All," and "I'll Never Smile Again," he tranquilized the nation; in the fifties boom, he was the slaphappy sound of good times ("Young at Heart," "Come Fly with Me," "Oh! Look at Me Now!"); in the sixties, he ushered in the optimism of the Kennedy era with "All the Way," "The Best Is Yet to Come," and "High Hopes," which was rewritten for JFK as his campaign song; and, even into the eighties, Sinatra was singing the tune of the smug, self-aggrandizing Reagan years with "My Way."

Over all those decades, Sinatra continually struggled to make his sound current. In the sixties, for example, under his own banner at Reprise, he produced a few great albums; at the same time, almost imperceptibly, as popular musical tastes underwent a seismic shift, Sinatra's records began to deteriorate into pick-up albums – collections of singles, like *That's Life*, and a particularly lazy effort, *Sinatra's Sinatra*, in which he just rerecorded his Capitol songs. (This prompted Jonathan Schwartz to quip, "Reprise Records, which Sinatra said stood for 'to play and play again,' really stood for 'to record and record again.' ") Times were changing, and Sinatra had to work to stay fresh. He tried bossa nova with the Brazilian Antonio Carlos Jobim; he mined the jazz seam in collaborations with Duke Ellington and Count Basie, which led to his touring with the Basie band and recording three albums with Basie, including the thrilling live album *Sinatra at the Sands*. By the mid-sixties, however, with the advent of the Beatles and the British invasion, radio stations had been colonized by rock and roll. One night, waiting to go on in Las Vegas, Sinatra looked at the audience and said to Jimmy Van Heusen, beside him, "Look at that. Why won't they buy the records?" "Of course, they were buying the records by the millions," says Jonathan Schwartz, to whom Van Heusen told the story. "What he really was saying was 'Why don't I have hit singles?' "

Sinatra did have a few brief moments of singles glory in the sixties: "Strangers in the Night," "That's Life," "My Way," and "Something Stupid," with his daughter Nancy, which went to number 1 on the charts in 1967 and became Sinatra's first gold single. He had long berated rock as "a rancid-smelling aphrodisiac," but now he tried to cross over and included in his repertoire works by Neil Sedaka, Joni Mitchell, Paul Simon, Stevie Wonder, and the Beatles. "Most of the rock songs Sinatra recorded came out dreadfully," the music critic John Rockwell writes in *Sinatra*. "With stiff vocal phrasing and, worse, hopelessly anachronistic instrumental arrangements." He was completely out of synch with the spirit of Joni Mitchell's "Both Sides Now"; he made a hash of Paul Simon's "Mrs. Robinson"; and although he finally got a good arrangement in a second version of George Harrison's "Something," he introduced the song for a long time as having been written by John Lennon and Paul McCartney.

He retired briefly in 1971, but by 1973, in response to thirty thousand fan letters and to his own agitated heart, he was back in the studio, and

soon afterward he was on the road again. He returned with a new toupee and a gutsy new repertoire. Instead of falling back on his standards, Sinatra learned difficult new songs: "Winners," "You Will Be My Music," "There Used to Be a Ballpark," "Noah," "Dream Away," and "Send in the Clowns." His voice was more staccato now, and the bands filled in the spaces. But he had kept faith with his public, and they with him. In 1975, Sinatra took a full page ad in the *Los Angeles Times*, reading, IT WAS A VERY GOOD YEAR: COUNTRIES: 8; CITIES: 30; ATTENDANCE: 483,261; TOTAL PERFORMANCES: 140; GROSS: $7,817,473. Sinatra still had some big innings left: the self-congratulatory bestselling *Trilogy* (1979), and the two multiplatinum *Duets* albums (1993–94), where he sang with contemporary pop stars like Barbra Streisand, Jimmy Buffett, Carly Simon, and Stevie Wonder. Sinatra was still reaching out for a new audience, and he found it, even if the product was well below his high standard. "I'm a belter now, baby," he was heard to tell the crowd in the late eighties. The last big notes he hit were in "New York, New York." Jonathan Schwartz says, "By the eighties, Sinatra was singing knuckleballs."

At Caesar's Palace, sometime in the early eighties, Shirley MacLaine caught Sinatra's show. "I don't know what was bugging him," she says of the evening's first show. "The magic wasn't there. He marked it. He couldn't wait to get out." Afterward, at dinner, Sinatra asked what she thought, and she gave him her version of a pep talk. "Frank, you really ought to remember how you got so many of us through a Second World War, and a New Deal, and gave us an education in music," she said. "Please don't just mark it, because it disrespects everything you meant to the whole country. You might seem to some like a ruin, but to most of us that ruin is a monument." Sinatra was dazzling in the second show. "His eyes just . . . It was like nobody had said that to him in a long time," MacLaine says.

In the early nineties, Sinatra began forgetting lyrics. "He'd apologize to the audience," his pianist Bill Miller says. "They'd say, 'Hey, Frank, we don't care.' And they don't. They want to see *him*." Miller goes on, "Then he had second thoughts. You'd see him shaking his head as if to say, 'I don't want them feeling sorry for me.'"

Sinatra's work is his legend; his legend is his work. Not surprisingly, he eschewed autobiography or an official biography. "There's too much

about my life I'm not proud of," he said. Inevitably, as children of the famous must, Sinatra's offspring all claimed their absent father by sustaining some part of his legacy. "You have to do it well," Nancy says. "You can't let people piss on it." She has written two elegantly produced books that are encomiums to the old man; Tina has produced a five-hour TV mini-series about Sinatra's life; and Frank, Jr., released the CD *As I Remember It* in 1996, with new orchestrations of Sinatra standards. Sinatra's story is hard to keep ideal, filled, as it is, with brigands, barbarity, and the brutalizing compromise of himself and others. But Sinatra kept on doing the only kind of penance he knew: singing.

In New York, on Sinatra's eightieth birthday, the Empire State Building glowed blue for Ol' Blue Eyes; in Los Angeles, at the Shrine Auditorium, Frank and Barbara Sinatra sat like the Sun King and his consort at a front-row table, while behind them the auditorium was packed to its chandeliers with the rich and famous in evening dress, attending a televised homage to Sinatra and his career. One by one, the grandees of popular American culture came forward to hymn his praises. The first to serenade him was Bruce Springsteen – one New Jersey Boss to another. "My first recollection of Frank's voice was coming out of a jukebox in a dark bar on a Sunday afternoon, when my mother and I went searching for my father," Springsteen said before launching into "Angel Eyes." "And I remember she said, 'Listen to that, that's Frank Sinatra. He's from New Jersey.' It was a voice filled with bad attitude, life, beauty, excitement, a nasty sense of freedom, sex, and a sad knowledge of the ways of the world. Every song seemed to have as its postscript, 'And if you don't like it, here's a punch in the kisser.' " Springsteen continued, "But it was the deep blueness of Frank's voice that affected me the most, and while his music became synonymous with black tie, good life, the best booze, women, sophistication, his blues voice was always the sound of hard luck and men late at night with the last ten dollars in their pockets trying to figure a way out. On behalf of all New Jersey, Frank, I want to say, 'Hail, brother, you sang out our soul.' "

Springsteen had met Sinatra for the first time a few months before that, at Sinatra's house in Beverly Hills. After supper, the guests gathered around the piano to sing. Among them were Bob Dylan, Steve Lawrence, Eydie Gormé, the singer Patti Scialfa (who is Springsteen's wife), the

producers George Schlatter and Mace Neufeld, and Tita Cahn. "You could feel Frank – you know when a thoroughbred is sort of wired up and is ready to race," Tita Cahn says. They harmonized for a while, and then someone suggested one of Sammy Cahn's early hits with Sinatra, "Guess I'll Hang My Tears Out to Dry." The group launched in:

> *When I want rain,*
> *I get sunny weather;*
> *I'm just as blue as the sky,*
> *Since love is gone,*
> *Can't pull myself together.*
> *Guess I'll hang my tears out to dry.*

"Hold it!" Sinatra interrupted. "You know I sing solo."
He finished the song alone.

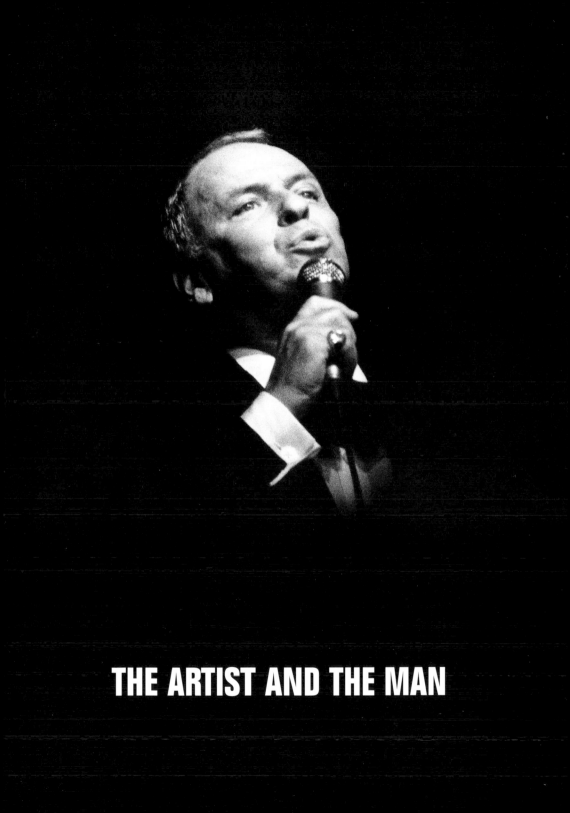

THE ARTIST AND THE MAN

The young Sinatra.
LILLIAN HIMMELFARB COLLECTION

PREVIOUS PAGE (AND PAGE 128):
Sinatra: "You begin to learn to use the lyrics of a song as a script, as a scene."
FRANK TETI/NEAL PETERS COLLECTION

Marty and Dolly Sinatra celebrate their fiftieth wedding anniversary, on February 9, 1963, with their famous son. "She was the force!" Sinatra said.
IRV WAGEN/THE HOBOKEN PUBLIC LIBRARY/FRANK SINATRA COLLECTION

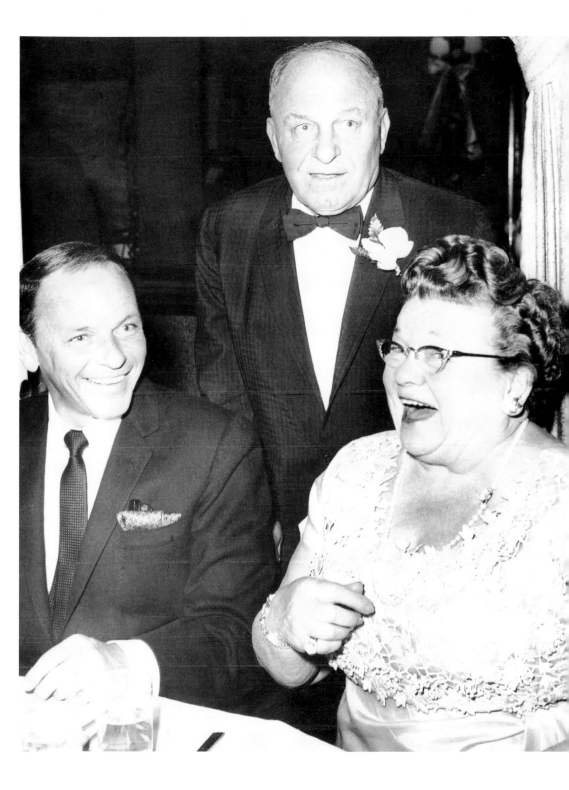

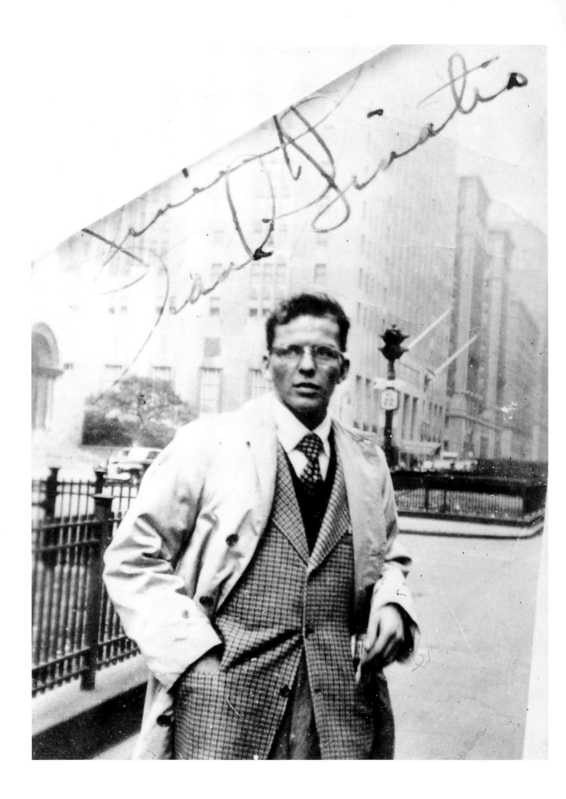

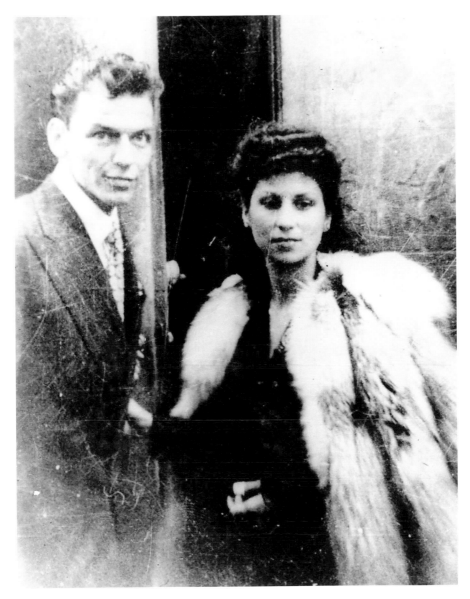

"Being with her was my only escape from what seemed like a grim world,"
Sinatra said of Nancy Barbato, his teenage sweetheart and first wife.

The "Top Wop" arrives: An early publicity shot places
Frank Sinatra on Park Avenue.

Sinatra's passion to connect and to be held by an audience released a bewildering energy from the public and from him.

Sinatra and his idol, Bing Crosby. "I knew I had to be a singer.
But I never wanted to sing like him," Sinatra said, "because
every kid on the block was boo-boo-booing like Crosby.
My voice was up higher, and I said, 'That's not for me.
I want to be a different kind of singer.'" Nevertheless,
in his very early radio days, Sinatra found himself
billed as "New Jersey's Bing Crosby of the Air."

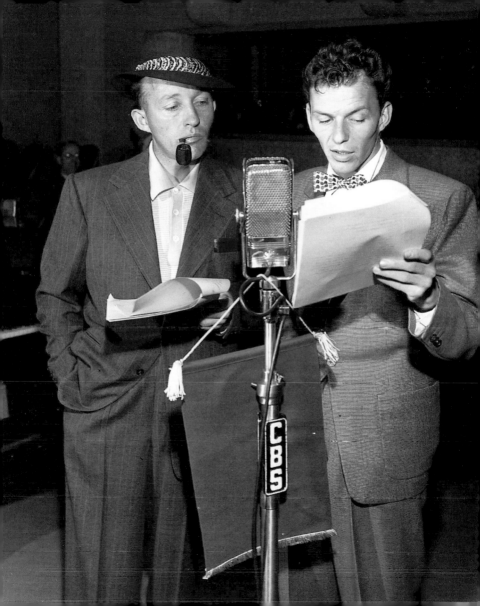

Sinatra and Tommy Dorsey. "Tommy was simpatico about vocalizing,"
Sinatra said, "because the instrument he played had the same
physical qualities as the human voice."

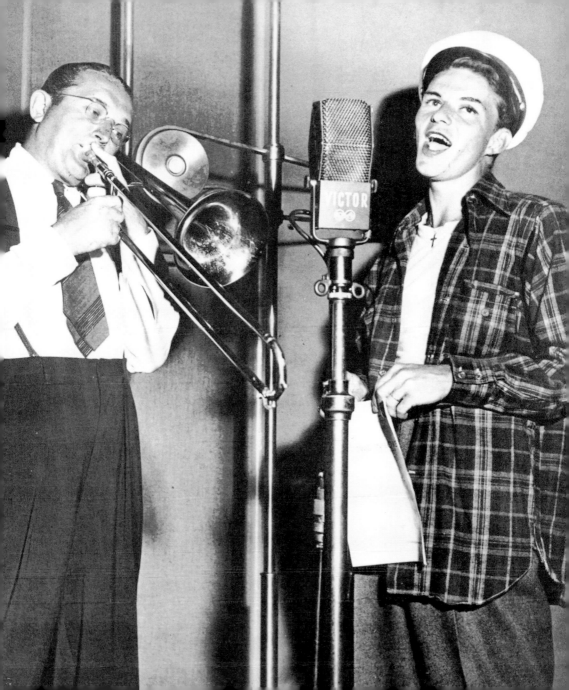

*Harry James (front row, center)
and his band, 1939. Sinatra
and Connie Haines flank the
lanky trumpeter, with whom
they toured for six months.
"Singing in a band is like
lifting weights," Sinatra said.
"You're conditioning yourself.
When it comes to professional
experience, there's nothing to
beat those one-nighter tours,
when you rotate between five
places around the clock – the
bus, your hotel room, the greasy-
spoon restaurant, the dressing
room – if any – and the
bandstand. Then back on the
bus to the next gig, maybe four
hundred miles away or more."*

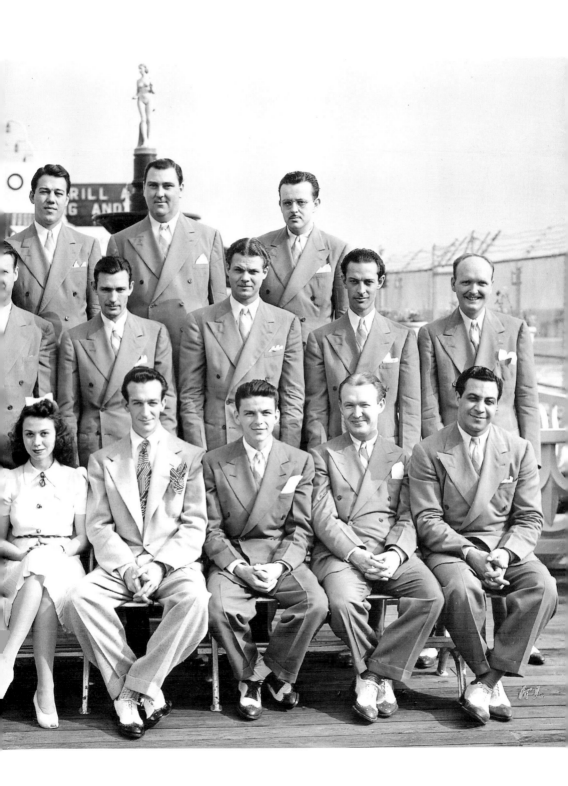

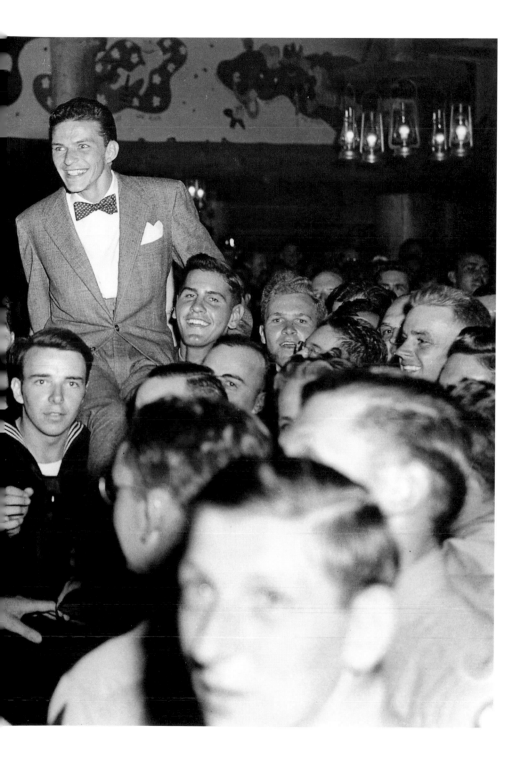

Sinatra worked his fame like no other performer. He is seen here at Steel Pier in Atlantic City in 1949 with child actress Vicki Gold celebrating his tenth anniversary in show business – the postcard map represents only a few dozen of the thousands of pieces of fan mail sent to Sinatra on the occasion. But by this time, Sinatra's decline had started – he would be undone by his own bad behavior and the fickle tastes of the same mass culture that he had helped invent.

AL GOLD/VICKI GOLD LEVI COLLECTION

PREVIOUS PAGES:

Because of a disability, Sinatra spent the war years in civilian clothes, a fact resented by many in the military and on the home front but not, apparently, by these sailors and soldiers. After the war, however, Sinatra could often be seen in uniform – in such films as It Happened in Brooklyn, From Here to Eternity, *and* Kings Go Forth.

THE LESTER GLASSNER
COLLECTION/NEAL PETERS

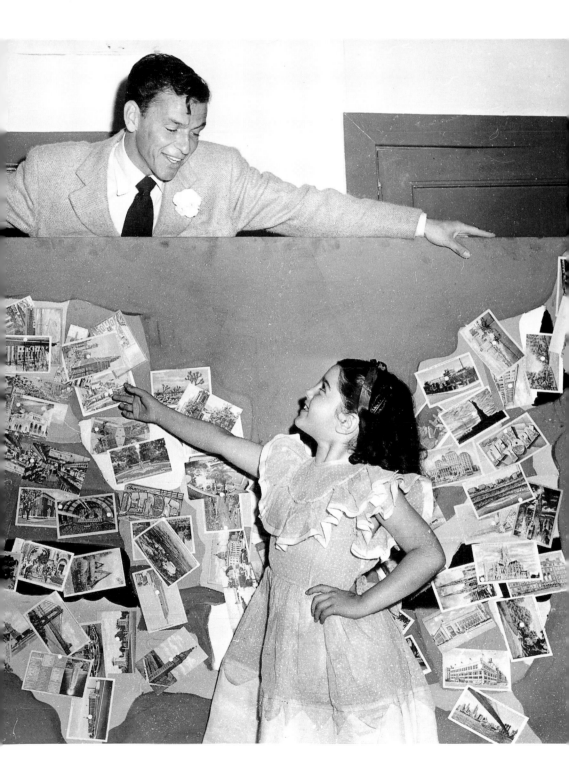

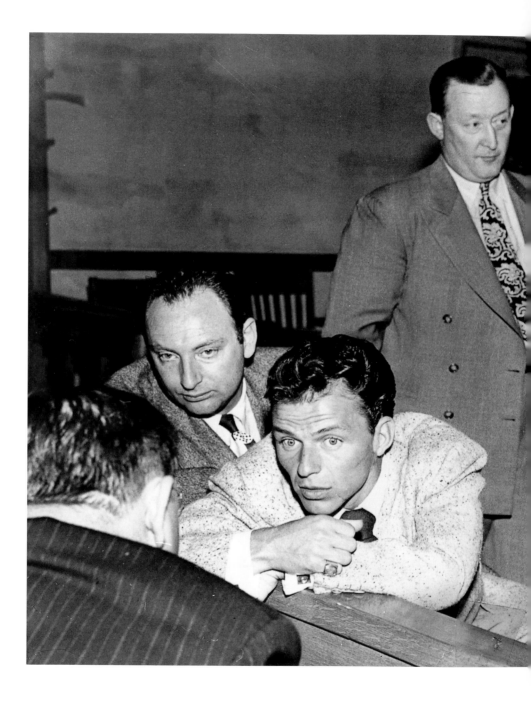

Sinatra lashed out at the journalists who were chronicling his decline. In the spring of 1947, he was charged with assaulting **Daily Mirror** *columnist Lee Mortimer (right). Sinatra settled out of court for $25,000.*

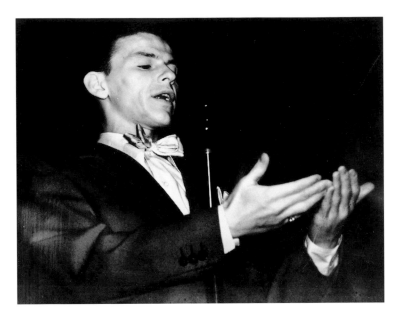

"Swoonatra": Sinatra onstage at the Paramount in New York City, November 5, 1944, where he first brought down the house in 1942. "Not since the days of Rudolph Valentino has American womanhood made such unabashed love to an entertainer," Time *wrote.*

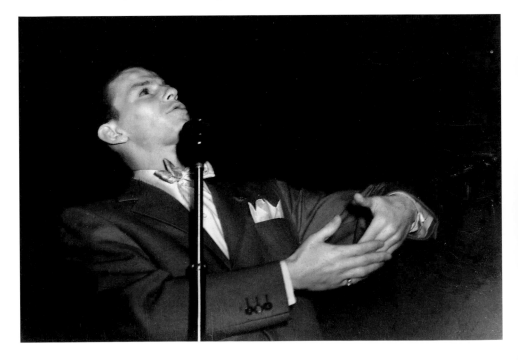

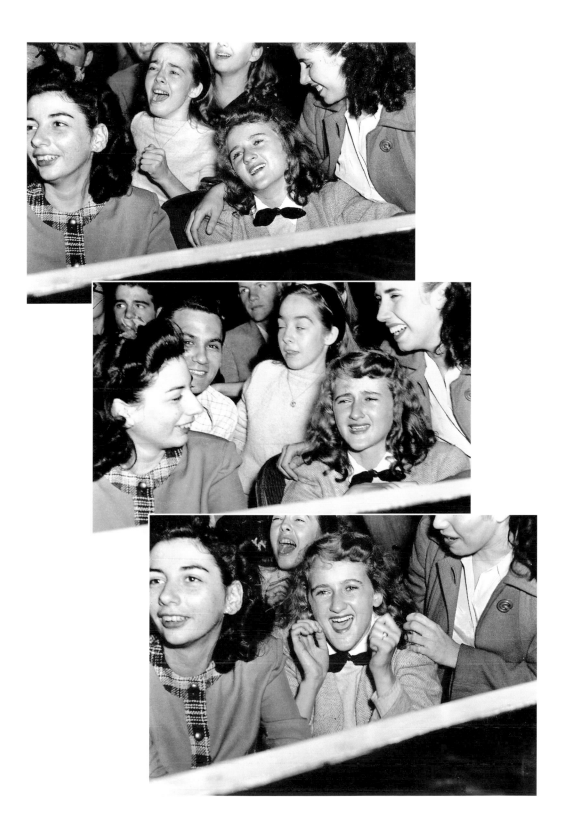

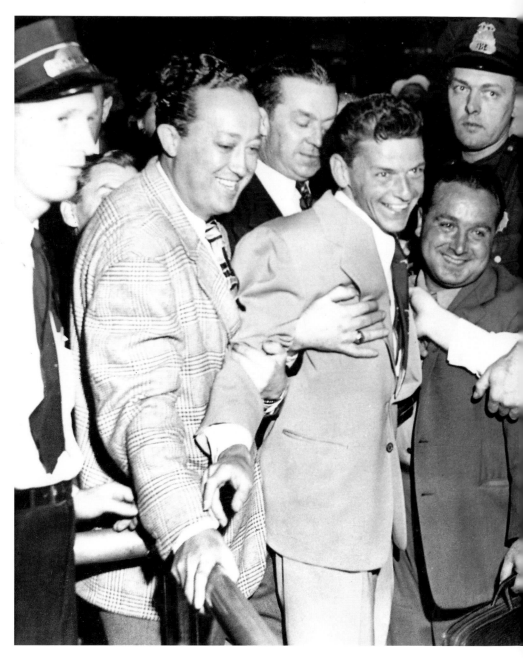

"The spontaneous reaction corresponds to no common understanding relating to tradition or technique of performance," a critic for the New York **Herald Tribune** *wrote about the hysteria Sinatra induced in his heyday.*

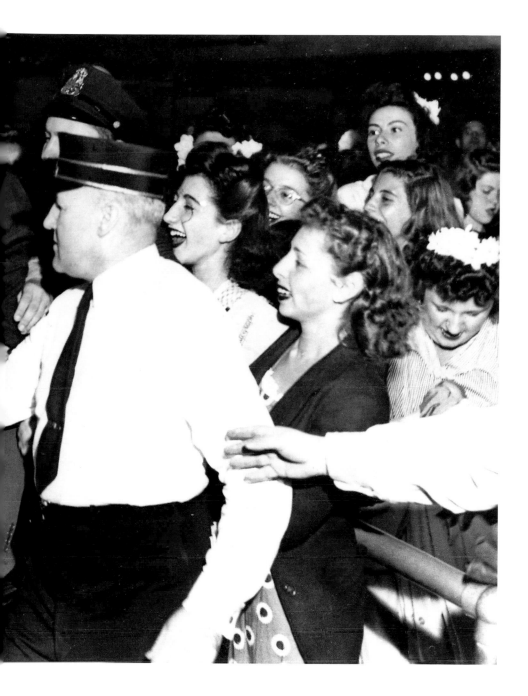

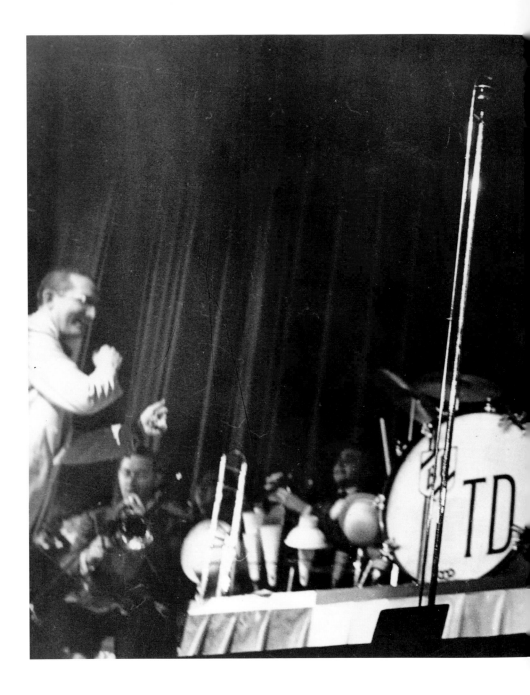

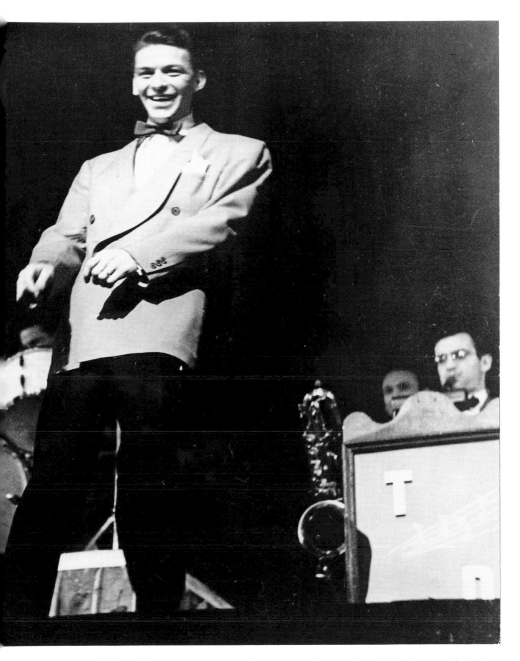

When Sinatra set out on his own in December 1942, he was bringing to a close the Big Band Era and ushering in the Vocalist's Era. "I hope you fall on your ass," bandleader Tommy Dorsey (far left) told him.

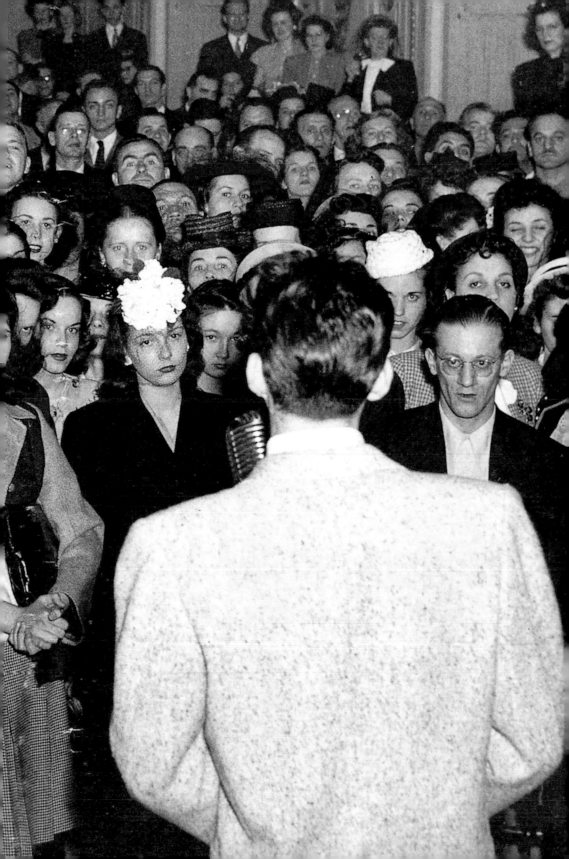

*"The blue-eyed ray": Sinatra's
eyes emitted an intense beam
of romance or rage — "a look
between 'I'll protect you' and
'Do you want to have an affair?'"
Shirley MacLaine remembers.
She adds: "You couldn't tell when
one stopped and the other started."*

PREVIOUS PAGES:
*The stillness, attention, and
unequivocal adoration that were
never there in his mother were
undeniable in the rapt enthusiasm
of his listeners. "His audience was
absolutely and without reservation
his," Shirley MacLaine writes in*
My Lucky Stars. *"He'd never
allow their attention or focus
to stray."*

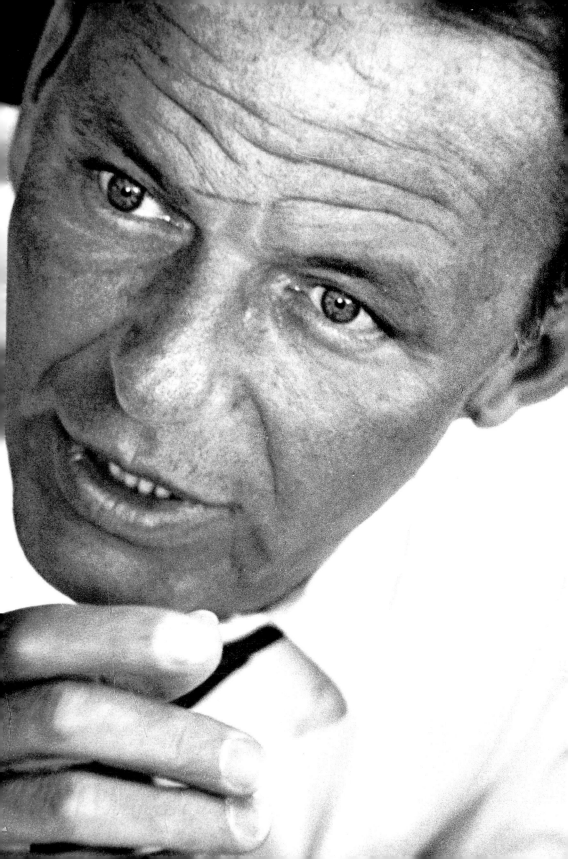

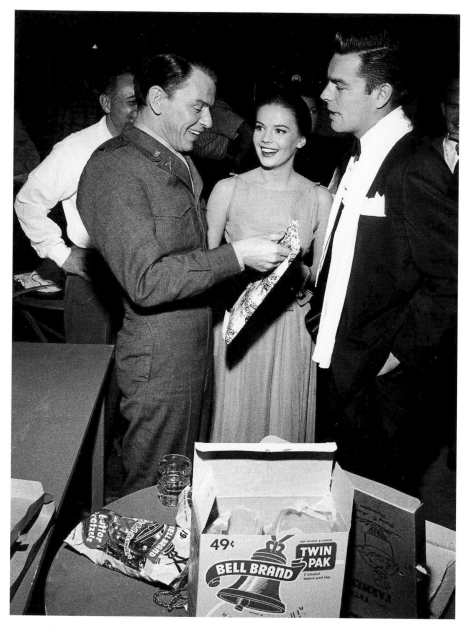

La bella figura: *Sinatra celebrates his forty-second birthday on the set of* Kings Go Forth *with Natalie Wood and Robert Wagner. Sinatra preferred giving the gifts. He was known for impulsive, awesome acts of generosity — "a kindness that was also an assertion of power," said Ruth Conte.*

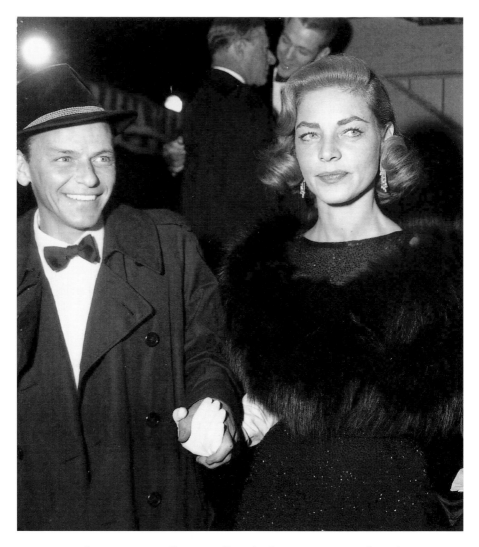

Sinatra and Lauren Bacall, 1957. "He had so many scars from his past lives – was so embittered by his failure with Ava – he was not about to take anything from a woman," Bacall wrote in By Myself.

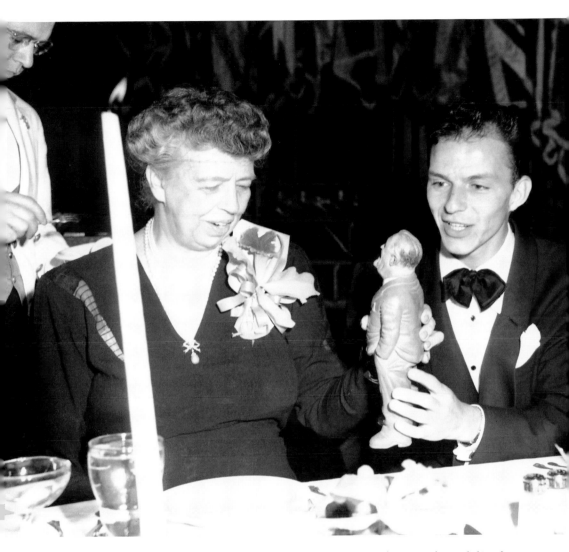

Dolly Sinatra was part of the Democratic party machine, and so idolized FDR that she named her son after him. When he first met Roosevelt, Sinatra introduced himself as "a little guy from Hoboken," but the president understood the power both of Sinatra's appeal and of popular music. Sinatra was soon lending his public support to FDR's fourth term, and he remained in touch with Eleanor Roosevelt after her husband's death – she was even a guest on his TV show in 1960, reciting the lyric of "High Hopes."

NAT DALLINGER

The habit of taking a tumbler of Jack Daniel's – "gasoline," in Sinatra slang – onstage began in the late fifties, and continued for decades.

FRANK TETI/NEAL PETERS COLLECTION

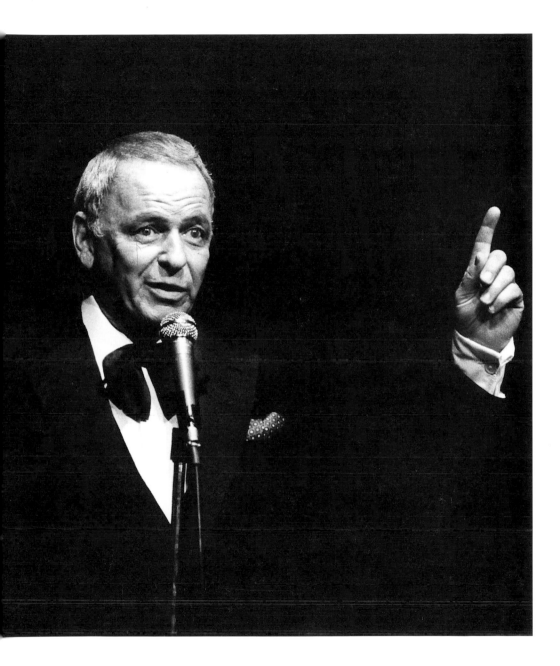

May 1943: Hasbrouck Heights, New Jersey – where Sinatra may be found shirtless in his driveway on a Sunday afternoon fixing daughter Nancy's doll carriage. The domestic idyll could not possibly last.

PAUL VUONO COLLECTION

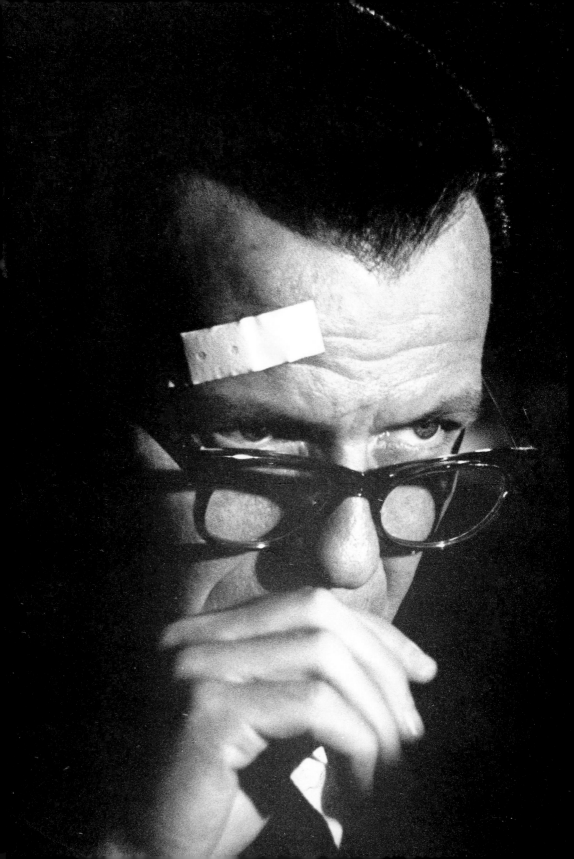

Watching rushes of The Manchurian Candidate *(1962),*
in which he played Bennett Marco, one of his best dramatic
performances. "He was absolutely ruthless about his own
performance," William Read Woodfield remembers.
"He saw it from the perspective of a businessman,
and this was an investment he'd made. "

© WILLIAM READ WOODFIELD/CPI

OVERLEAF:

With Laurence Harvey in The Manchurian Candidate, *whose*
theme of presidential assassination was thought too politically
volatile by Arthur Krim, the head of United Artists (and the
national finance chairman of the Democratic party); Krim refused
to distribute it. Sinatra went directly to JFK. "That's the only way
that the film got made," said Richard Condon, on whose novel the
movie was based. "It took Frank going directly to Jack Kennedy."
Sinatra owned the prints of The Manchurian Candidate *and*
withdrew the film from circulation after JFK's murder.

NEAL PETERS COLLECTION

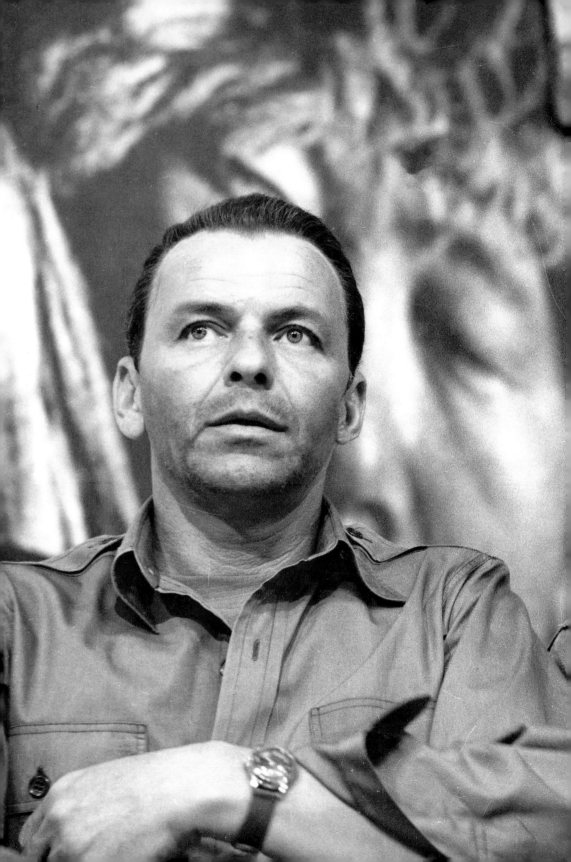

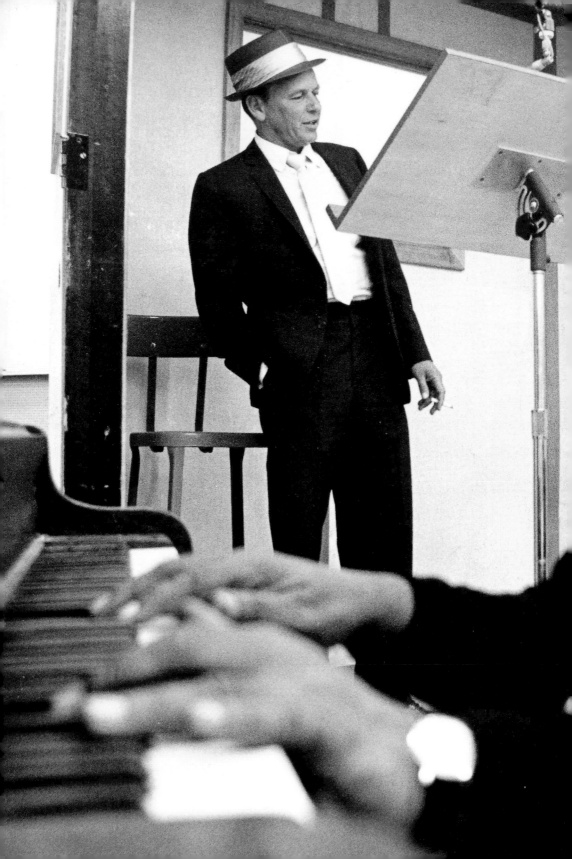

Sinatra and Count Basie,
with whom he toured and
cut some of his best records
in the sixties. Sinatra: "Basie,
as we all know, epitomizes
the greatest kind of tempo
for swing, in jazz. It's a joy,
because all I had to do was
just stay up on the crest of
the sound and move along
with it. It just carries
you right through."

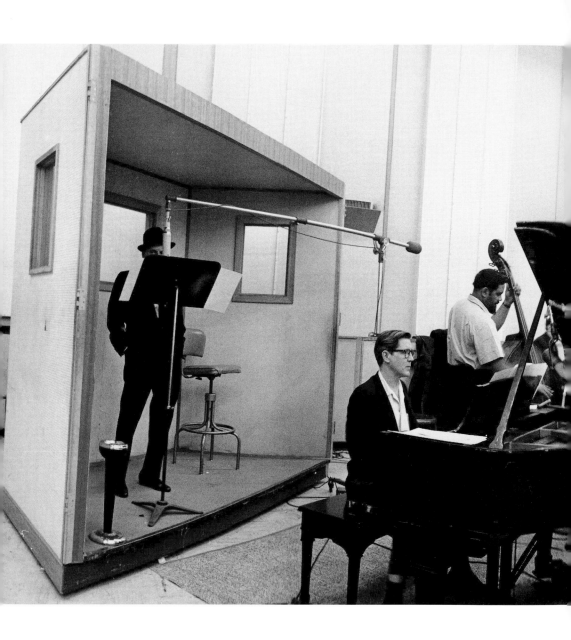

The man in the booth runs the room.
© WILLIAM READ WOODFIELD/CPI

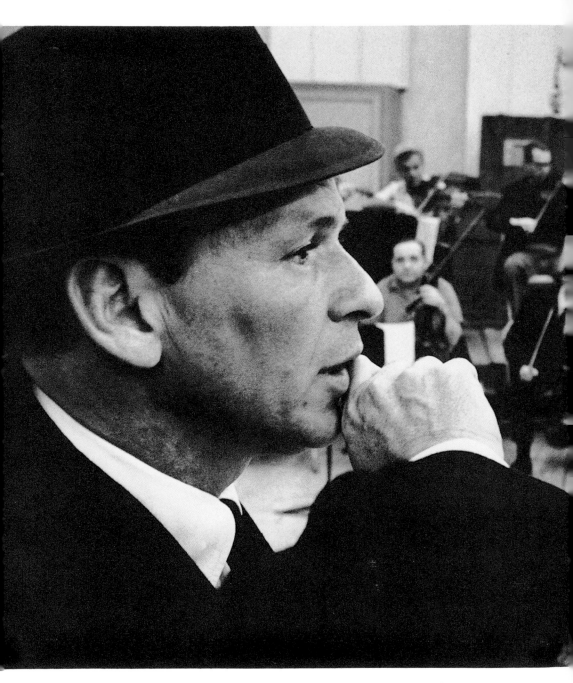

Supervising a 1957 recording session. "When you hear a Frank Sinatra album, it's the product of Frank Sinatra's head," Nelson Riddle said.

© WILLIAM READ WOODFIELD/CPI

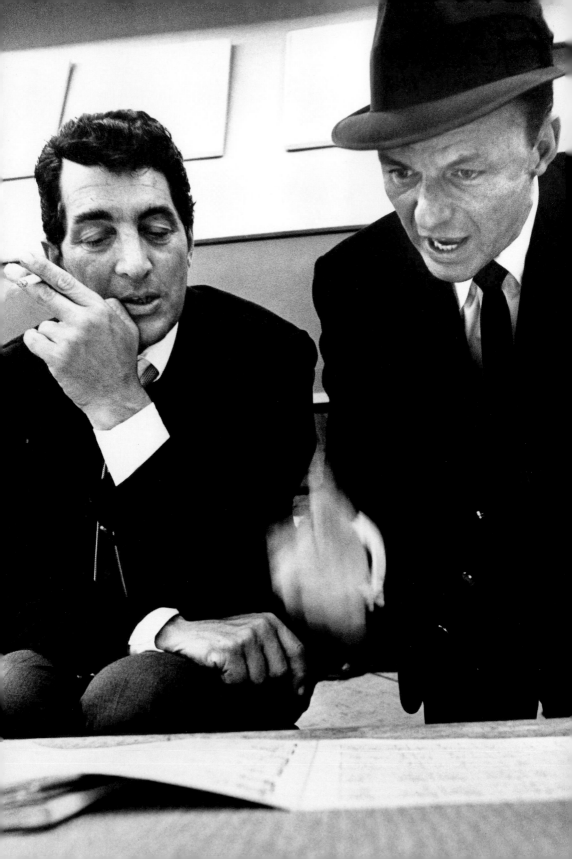

William Read Woodfield remembers Sinatra "berating" Dean Martin for "screwing up" at this 1957 recording session. Martin soon got it right, however, and within three days of the taping, over $100,000 worth of records had been pressed and shipped. "Frank and I are brothers, right," Dean Martin said. "We cut the top of our thumbs and became blood brothers. He wanted to cut the wrist. I said, 'What are you, crazy? No, here's good enough.'"

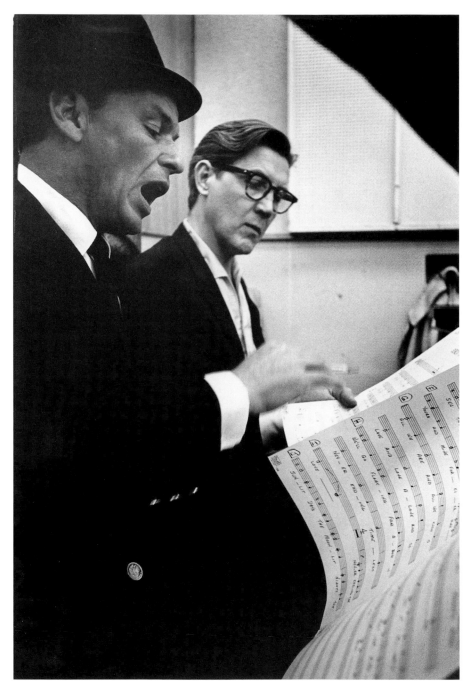

Singing it through for pianist Bill "Sunshine" Miller, 1957.

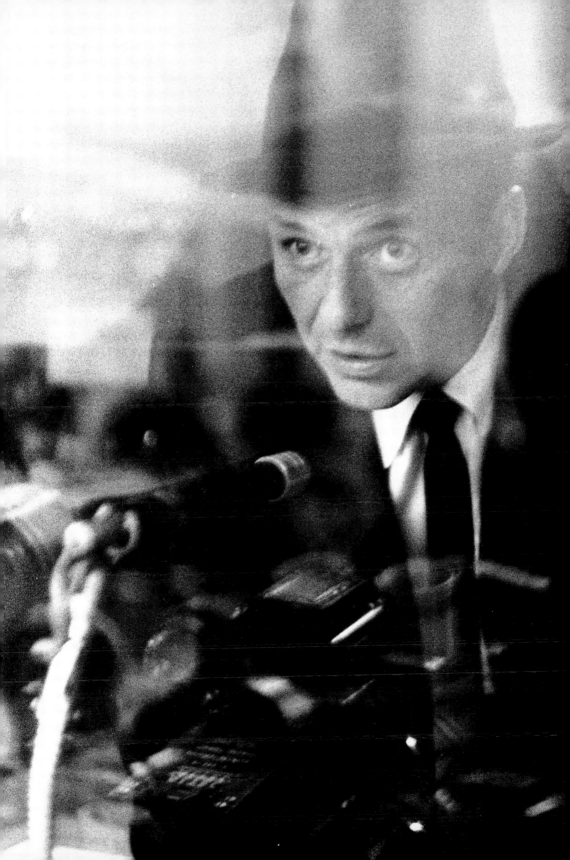

The Chairman.
© WILLIAM READ WOODFIELD/CPI

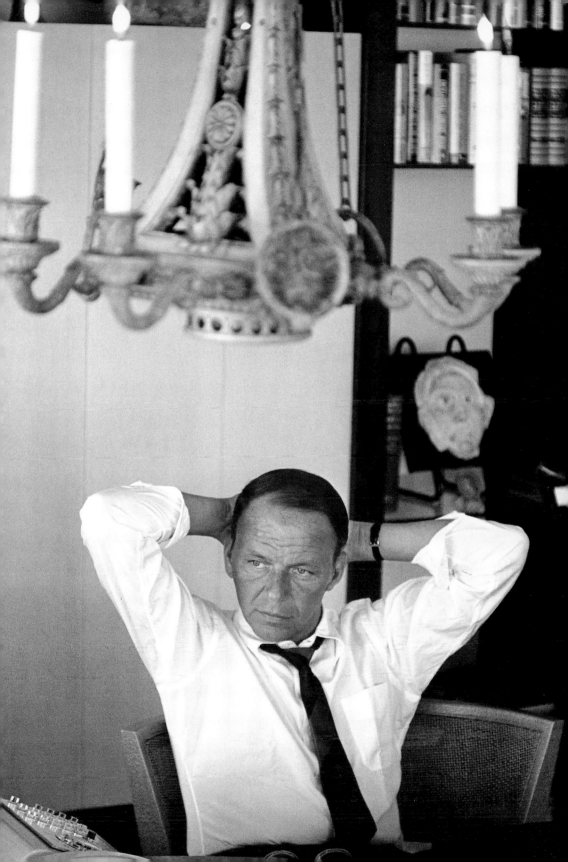

"Sinatra, Inc." *was running at full tilt in 1962, with three films in release –*
The Road to Hong Kong, The Manchurian Candidate, *and* Sergeants 3.

The Board. Sinatra directs a room full of PR men, accountants, producers, and legal and other advisers, 1962.

Dressing room, Fontainebleau Hotel, Miami Beach. Waiting to go on.

OVERLEAF: *Frank Sinatra in performance, Las Vegas, 1966.*
RODDY McDOWELL © HARLEQUIN ENTERPRISES LTD

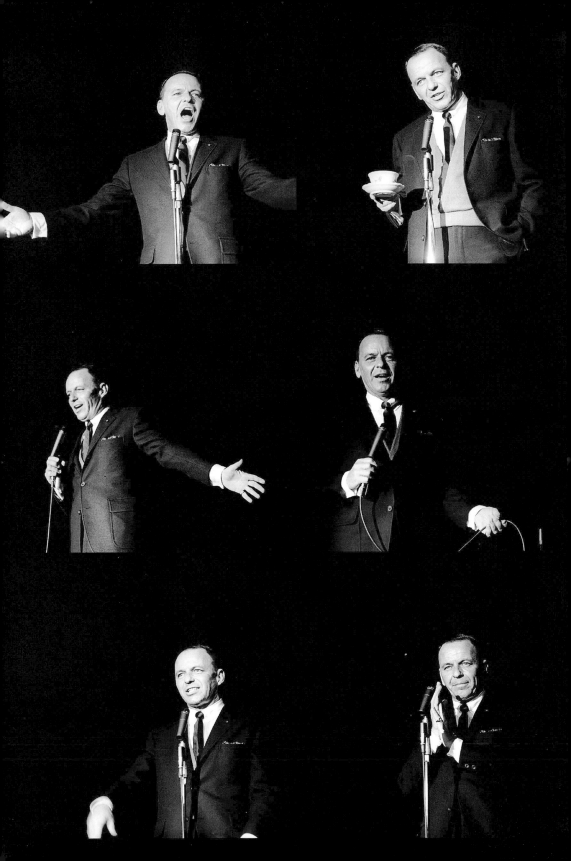

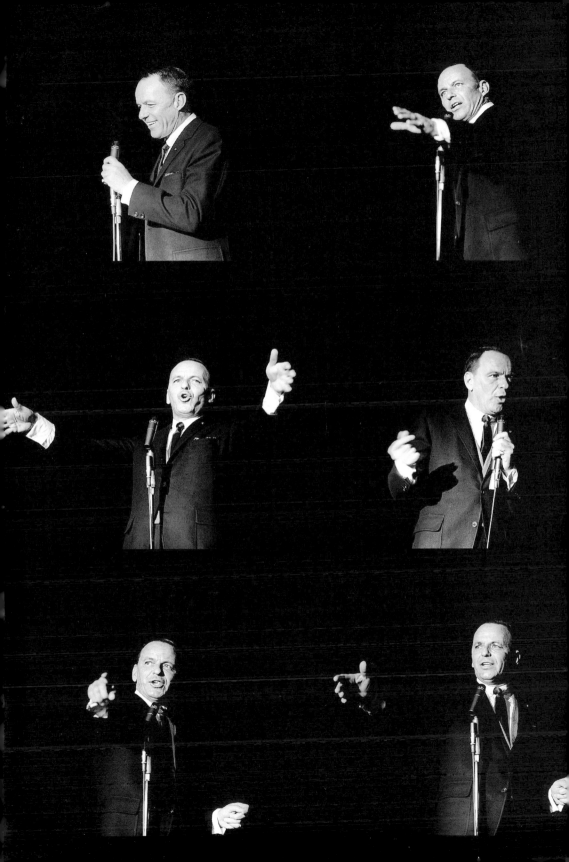

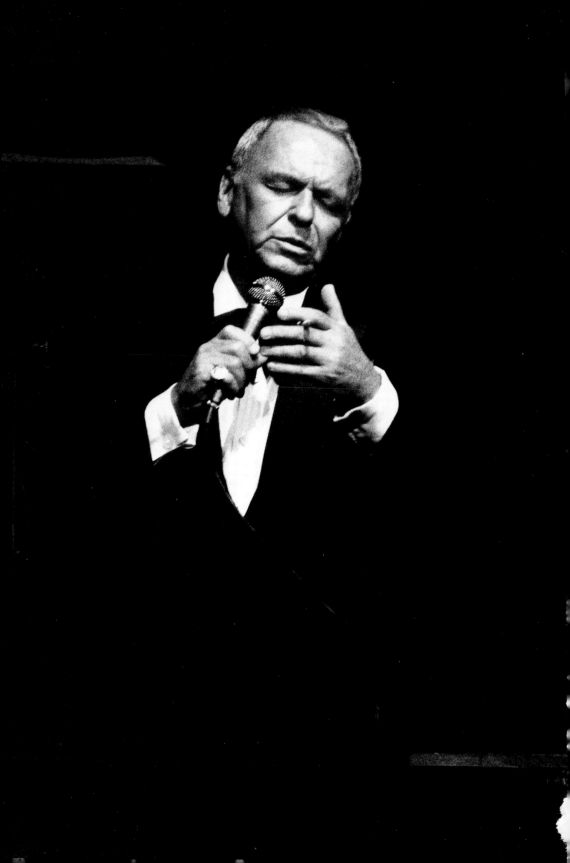